CARL HEILMAN II
THE LANDSCAPE PHOTOGRAPHY FIELD GUIDE

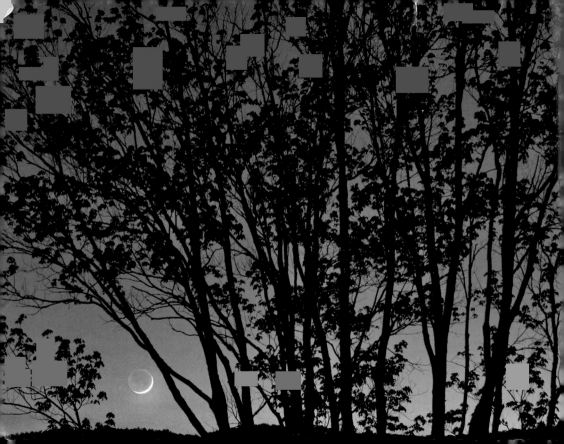

CARL HEILMAN II
THE LANDSCAPE PHOTOGRAPHY FIELD GUIDE

Capturing the **great outdoors** with your digital SLR camera

AMSTERDAM • BOSTON • HEIDELBERG • LONDON
NEW YORK • OXFORD • PARIS • SAN DIEGO
SAN FRANCISCO • SINGAPORE • SYDNEY • TOKYO
Focal Press is an imprint of Elsevier

ELSEVIER

Focal
Press

Focal Press is an imprint of Elsevier Inc.
225 Wyman Street, Waltham
MA 02451, USA

Copyright © 2011 The Ilex Press Ltd.
All rights reserved
Photography copyright Carl Heilman II

This book was conceived, designed, and produced by
Ilex Press Limited
210 High Street, Lewes, BN7 2NS, UK

Publisher: Alastair Campbell
Creative Director: Peter Bridgewater
Associate Publisher: Adam Juniper
Managing Editor: Natalia Price-Cabrera
Editorial Assistant: Tara Gallagher
Art Director: James Hollywell
Designer: Jon Allan
Color Origination: Ivy Press Reprographics

Permissions may be sought directly from Elsevier's Science & Technology
Rights Department in Oxford, UK: Phone (+44) (0) 1865 843830; Fax (+44) (0)
1865 853333; Email: permissions@elsevier.com. Alternatively visit the Science
and Technology Books website at *www.elsevierdirect.com/rights* for further
information

Notice: No responsibility is assumed by the publisher for any injury and/or
damage to persons or property as a matter of products liability, negligence or
otherwise, or from any use or operation of any methods, products, instructions
or ideas contained in the material herein.

Trademarks/Registered Trademarks:
Brand names mentioned in this book are protected
by their respective trademarks and are acknowledged.

Library of Congress Control Number:
A catalog record for this book is available from the Library of Congress.

ISBN: 978-0-240819-22-8

For information on all Focal Press publications visit our website at:
www.focalpress.com

Printed and bound in China

10 11 12 13 14 5 4 3 2 1

CONTENTS

Introduction

Equipment

Camera Features, Formats, and Sensors
Setting Up Your Camera
Choosing Lenses and Focal Length
Tripod and Cable Release
Filters, Flash, and Accessories
Outdoor Gear and Safety
Finding the Best Locations

Technique

Aperture and Depth of Field
Shutter and Motion
ISO Options
Creating the Best Exposure
White Balance
Understanding Histograms
Bracketing and HDR
Manual Focus vs. AutoFocus
Shooting for Post Production
Video Tips

Shooting 74

Perfect Pictures Every Time 76
Visualization 78
Composition Guidelines 80
Lines, Textures, and Patterns 86
3D from 2D 90
Panoramas and Image Blends 92
A Closer View 94
Energy and Emotion 98
Fine Art Imagination 102
A Sense of Place 106
Weather 108
The Four Seasons 114
Daylight Locations and Lighting 118
Nighttime Locations and Lighting 130
Photographing People 138
Working with Wildlife 142
Aerial Photography 146
Underwater Photography 148

Creative Effects 150

Selective Focus and Diffusion 152
Panning and Motion Blur 156
Multiple Exposures and Image Compositing 160
Interval Timer and Time-lapse 162
Flash and Artificial Light 164

Editing Workflow 168

Storage and Backing Up 170
Image Review and Database Processing 172
Image Editing and Enhancement 174

Reference 184

Digital Workflow 184
Shooting Guidelines, Formulas, and Tips 186
Glossary 188
Index 190
Acknowledgments 192

INTRODUCTION

In photography, as in life, "keeping it simple" can be a complicated business. When the photographer understands the mechanics and principles of the aperture and shutter, "keeping it simple" becomes much easier, allowing the photographer to fully explore the art of composition and diversity of lighting available to take the best shot possible.

Asking the creative question, "what if?" opens up endless creative choices: "What if I tried a different viewpoint? What if I used a different lens, aperture, shutter speed, focus point, or lighting?" While this field guide offers many useful guidelines, simply honing composition to the eye-catching details helps produce the best images.

Equipment

Technique

Shooting

Creative Effects

Editing Workflow

Reference

The same goes for equipment and techniques. Keeping equipment and photo techniques simple and functional lets us expand our creativity with less thought to mechanics and equipment setup. Today's digital technology helps put the fun back into photography by making it easier to capture the moment and explore our photographic passions.

Even though digital cameras appear more complicated than their film counterparts, don't be scared into shooting only in Program mode. Once you understand the principles of the aperture and shutter, and their relation with ISO, working with Aperture Priority or Shutter Priority mode, Evaluative Metering, and Exposure Compensation opens up endless creative options with you in full control of each click of the shutter. The immediacy of digital cameras allows you to check results and fine-tune the shot, offering the potential to bring back the best images possible.

LEFT
Magic hour light, with its shadows and softness, is some of the finest light of the day. 12mm (APS); ISO 200; 1/125 sec at f/10.

EQUIPMENT

This is a great time to be enjoying the craft of photography. Digital technology has evolved to a point where everything from the built-in cameras in phones and palm-sized video devices, to highly sophisticated digital single-lens-reflex cameras (DSLRs) can be used to create some great images. Since a 6–8 megapixel image is roughly equivalent to the quality of 35mm film, the highly refined digital sensors and software found in some of the simplest point-and-shoot cameras capture images that are at least as good as what could be done with slides and negatives shot with a 35mm SLR. Video capability offers even greater options for shooting.

While compact iPhones and point-and-shoot cameras offer flexibility, portability, and ease of use in an incredibly compact package, the digital single-lens-reflex style camera with interchangeable lenses and manual as well as automatic controls, provides the greatest flexibility and adjustment for creative outdoor photography. Understanding the basic principles behind the use of aperture to manage depth of field, and the shutter to control motion, puts you fully in charge of your camera. It's all about developing the ability to shoot perfect pictures every time and learning how to create photos by choice—not by chance.

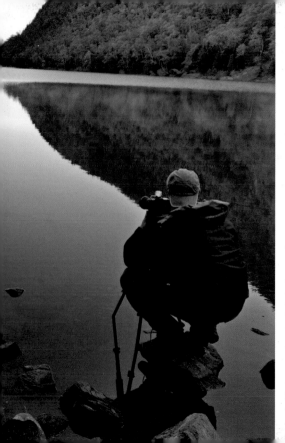

EQUIPMENT

9

Technique

Shooting

Creative Effects

Editing Workflow

Reference

Camera accessories have evolved along with the camera technology. There is a number of tripods that offer the utmost flexibility and stability in all kinds of shooting situations and models that can fit all budgets. Camera packs come in all shapes and sizes, with some designs that even use dry-bag technology to keep camera equipment safe in all kinds of weather conditions. All-in-one zoom lens designs combine extra flexibility for shooting with hardly ever having to change a lens. Portable storage and viewers offer options for editing and checking composition in the field. Filters, flash and artificial lighting, extension tubes, unique lens setups, and software and digital imaging options provide an incredible array of tools that offer everyone the capability to pursue some of the wildest creative ideas.

As I cover each segment of camera equipment and accessories, I will pare down the suggestions to what I feel are the essential elements that offer the greatest flexibility for outdoor photography. It is easy to add on personal choices from there to get the equipment that is just right for you. The goal is to put you in control of the photograph at each step, from conception, through the process of shooting, to the final publishing and sharing of the image. With digital technology, this level of control is within everybody's reach!

LEFT

Looking for the "perfect picture every time." Set up at Cascade Lake, Adirondack Park, NY. 18mm (APS); ISO 400; 1/125 sec at ƒ/8.

Camera Features, Formats, and Sensors

It's very easy to get caught up in the overwhelming variety and gadgetry of today's high tech cameras. However, I think it is more important to look for the few essential features that offer full creative control of each photo and create the best quality image files to work with. Even with the most sophisticated cameras, the creative options available are still directly related to the shutter and the aperture. While both the aperture and the shutter are used to adjust the intensity of light reaching the sensor, the size of the aperture opening determines the amount of depth of field in a scene, and the speed of the shutter controls how motion is captured and portrayed.

There are only a few camera features and options I work with and rely on for all of the images I shoot—Aperture Priority mode, Shutter Priority mode, Manual mode, Manual ISO, Exposure Compensation, auto-bracketing, and the Raw file option. All of these primary camera options can be found in a few of the point-and-shoot cameras, and in nearly all DSLR cameras. While a feature like ultrasonic sensor cleaning is essential, having a depth-of-field preview button can be helpful but isn't absolutely necessary. How many additional "enhancements" you choose depends on how much image control and flexibility you would like, balanced with portability and cost. Your final camera choice is dependent on what type of camera you want to work with, how many options you prefer for shooting, and how adaptable it will be to all kinds of weather and lighting conditions—an important consideration for landscape photography.

Every camera utilizes an aperture and a shutter to expose an image. Since it is most important to have full control of both the aperture opening and the shutter speed, I always make sure a camera has settings for both Aperture Priority and Shutter Priority, and also has a fully manual mode. The program modes that are built into consumer cameras today simply work with different combinations of the aperture, shutter, ISO, and Exposure Compensation. Learning and

LEFT

I chose a specific shutter speed for just the right amount of motion with the water, and shot this image using Shutter Priority mode. 170mm (APS); ISO 400; 1/8 sec at $f/22$.

EQUIPMENT

11

Technique

Shooting

Creative Effects

Editing Workflow

Reference

ABOVE

This film camera features all of the controls I use regularly with my DSLR—aperture size, shutter speed, Exposure Compensation, ISO settings, and hyperfocal settings (note the colored bands on the lens that are related to the various aperture sizes).

LEFT TO RIGHT

Camera options are many and varied; the Nikon D3000S with APS sensor size is a good DSLR option, as is the Olympus "Pen" E-P2 micro Four Thirds model, while high-performance point-and-shoot options include the Canon PowerShot SX30 IS.

understanding the principles of these camera features offers greater image control than using the program modes and lets you work to the limits of the camera and lens.

When photographing landscapes and situations where depth of field is most important, I use Aperture Priority mode so I can choose my depth of field, and the camera will select the appropriate shutter speed for the light I'm in. When photographing an activity—wildlife, people, or an image where the control of motion is most important—I use Shutter Priority mode so I can choose the shutter speed, and the camera selects the aperture setting. Manual mode has the option of the Bulb setting for extra long exposures. Manual can also be used for matching sequential exposures when creating panoramas, or for any situation where you want to fully control all of the settings.

Understanding how ISO settings affect an exposure adds a way to work with aperture and shutter settings in varying

intensities of light. While I typically prefer to work with a low ISO speed of 100–250 to maintain the best image quality, higher ISO settings offer options to work in low-light situations and still be able to adjust and control both motion and depth of field. While higher ISO image quality isn't as sharp and noise-free as images shot at lower settings, it does offer a way to capture images of scenes that were next to impossible to photograph with film.

Exposure Compensation is a feature I use regularly that lets me fine-tune image exposure. A camera's built-in light meter balances out the various tones of light in a scene to an average 18% gray tonal exposure. While this often works well, whenever there is a predominantly white or light-colored area in a scene, such as in a snow or beach scene, a person must overexpose from the normal camera metering in order for the snow or sand to appear as bright as it does to the eye. If a scene has a predominance of denser, darker regions, then the scene needs

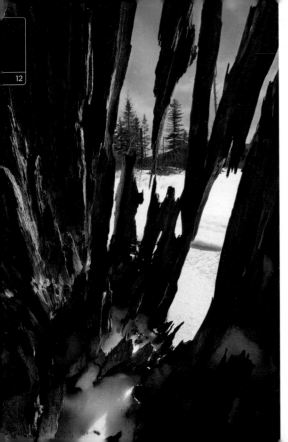

to be underexposed to compensate for the camera's metering. Exposure Compensation is an easy way to work with the camera's automatic features, and to fine-tune exposures. It's helpful to be able to compensate by at least 2 stops above and below the normal exposure.

Auto-bracketing is another way to get the right exposure, as well as to obtain the range of exposures needed for HDR work (High Dynamic Range). Bracketing is the process of taking multiple shots of the same scene at different exposure settings. I use the auto-bracketing feature for as much as 90% of my shooting. Auto-bracketing three shots (or more) at least 1 stop apart, gives a range of exposures for choosing the best single image, or having a range of image information for compositing details from different exposures into one image using HDR techniques. It's important to be able to auto-bracket by at least 2 full stops above and below normal, and 3 or more is even better!

While a properly exposed JPEG file with detail in both highlights and shadows offers many options for publishing, Raw is the best file format to work from for doing image enhancement work. If you prefer shooting JPEGs, one option is to shoot using the Raw/JPEG option so you get both. Shooting both JPEG and Raw at once provides the best image file to

LEFT

In order to be in apparent focus from just inches in front of the camera to infinity, the aperture setting and depth of field were most important, so this image was shot using Aperture Priority mode. HDR composite with a base exposure at 12mm (APS); ISO 250; 1/200 sec at $f/25$.

Technique
Shooting
Creative Effects
Editing Workflow
Reference

20mm lens full-frame

20mm lens APS-C 1.5x

20mm lens Four Thirds 2×

Full-frame
35 x 24mm

APS-C Nikon
23.6 x 15.8mm

Four Thirds
17.3 x 13mm

Point and Shoot
1/1.6" 1/2.5"
7.78 x 5.76 x
5.83mm 4.29mm

ABOVE

Relative sizes of different sensors/crop factor.

work from when you do get those "perfect" images and want to do some additional color enhancements.

While most image sensors in DSLRs and some point-and-shoots are now CMOS, some still use CCD sensors. Although there is little difference in image quality between a CCD and CMOS sensor in normal shooting situations, a CMOS sensor uses less power and operates at a cooler temperature so there are fewer noise issues in images during extra-long exposure situations. Also, since the CMOS sensors are so energy efficient, battery life is at least double that of cameras with a CCD sensor. I suggest cameras with sensors that are at least 10 megapixels in size.

In addition to the type of sensor, there is also a choice in the sensor size. There are three common sensor formats used in DSLR-style cameras. A full-frame sensor is about the same size as a 35mm slide, while the designed-for-digital Four Thirds sensor is approximately half the height and width of a full-frame sensor. The most common APS sensor sizes are roughly in between the

full-frame and Four Thirds formats. Point-and-shoot camera sensors are considerably smaller than any of the DSLR sensors.

When comparing differently sized sensors that have the same megapixel count, larger sensors have proportionately larger pixels. Proportionately larger pixels offer greater dynamic range and less noise issues at higher ISO settings, so a full-frame sensor with larger pixels is able to capture cleaner images in lower light—an advantage for photographing wildlife, weddings, sports, and photojournalism.

However, there are depth of field advantages with the smaller sensors. The shorter the focal length of a lens, the greater its depth of field. Since the cropped view of a camera with a smaller sensor requires a wider angle lens (shorter focal length) to provide the same field of view as a camera with a full-frame sensor, there is a greater depth of field for the same field of view. Using an APS format sensor for landscapes, macros, and telephoto shots offers greater flexibility in composition because of this depth of field advantage. Since most landscape images are shot at low ISO settings, and image quality at a low ISO is pretty much the same with any of the sensor sizes, APS or Four Thirds sensors are quite sufficient for landscape photography and offer greater options for composition than full-frame.

Since more is better when it comes to an LCD screen, look for one that is at least three inches diagonally with a high pixel count for sharp, bright image playback. It's even better if the LCD and/or the viewfinder shows 100% of what the image will be. That way there is less concern during composition for any

ABOVE
Working with LiveView and the viewfinder grid to check image composition.

LEFT
I pushed the ISO to 1000 for this image to be able to take the photo in the soft and overcast early-morning light. 380mm (APS); ISO 1000; 1/40 sec at *f*/5.6.

stray branches or other details that work their way into the edges of an image. A LiveView option makes it much easier to photograph from angles where it's tough to see through the viewfinder, and having an articulating LCD screen offers even greater shooting flexibility.

Most cameras today offer an Evaluative (or Matrix) Metering mode in addition to the Center-weighted Metering and Spot Metering modes. To keep things simple, I tend to use the evaluative setting almost 100% of the time. I know how the camera will meter in most situations and just use Exposure Compensation to correct for the camera reading as needed.

Even some of the best dampened mirrors can still cause a noticeable motion blur in both macro and telephoto images.

Having the ability to lock the mirror in an open position is a great advantage for shooting magnified images. The mirror lock-up feature swings the mirror up when the shutter release button is first pressed. Pressing it a second time opens the shutter to capture the exposure. This works best with the camera mounted on a tripod, with a cable release to trigger the mirror and shutter.

Nikon's Exposure Delay option is another way to let the camera settle down after pressing the shutter release button, or for adding a quieting pause with a cable release. With this feature turned on, the camera mirror swings out of the way when the shutter is triggered. After a one second pause, giving the camera enough time to settle any movement, the camera

automatically opens the shutter to capture the exposure. Using Exposure Delay can be a quick alternative to hooking up a cable release when the camera is in a fixed position.

A self-timer can help control camera shake when pressing the shutter release by hand, but it will not minimize mirror vibration issues for macro or telephoto shots. The camera's self-timer is a programmable delay for activating the camera to take a photo. However, the self-timer has no delay between the time the mirror swings up and the shutter opens, only a delay from the time the shutter release is pressed to when the photo is taken.

When working with tripods, it is essential to have a place on the camera to attach a remote cable release—either manual or electronic. A high percentage of my landscape images are taken in lower light situations—or at the minimum aperture—with corresponding slower shutter speeds. Many times the shutter speed is slow enough that the camera must be on a tripod. A cable release is the only way to be able to trigger the shutter at precisely the right moment, without potentially moving the camera during or between exposures.

A couple of menu features I use a lot for image playback are the overexposed flashing highlights setting, and a full-screen histogram. Some cameras also show underexposed shadow areas. The flashing highlights are an easy way to see at a glance whether all of the highlight detail was captured—and if not, what proportion was not. Using this in conjunction with a full-screen luminance histogram gives a full readout on how all of the tonal values were captured in the image.

Suggested camera features for landscape photography

All of the following creative and shooting options are applicable to DSLR style cameras with interchangeable lenses, and many of them also apply to more advanced point-and-shoot cameras as well. While I consider the first six as most important, the others are strongly suggested as well.

- Aperture Priority and Shutter Priority modes
- Manual mode
- Manual ISO adjustment
- Exposure Compensation feature with at least 3 stops +/-
- Autoexposure Bracketing with a range of at least 2 stops +/-
- Raw image file option
- 10 megapixel or larger CMOS sensor
- Ultrasonic sensor cleaning
- 100% viewfinder is quite helpful but not necessary
- Viewfinder grid option is helpful
- 3″ diagonal or larger hi-res LCD viewing screen
- LiveView option
- Matrix (Evaluative) Multi-segment Metering
- Mirror lock-up feature and/or Exposure Delay mode
- Overexposed highlights display
- Full-screen luminance histogram
- Autofocus/manual override
- Flash—either built-in, or via accessory shoe
- Tripod mount
- Remote cable release capability
- Depth-of-field preview button
- DSLR with interchangeable lens system is preferable

Setting Up Your Camera

Camera Menus and Setup Options

While the basic functions of a digital camera still only adjust the aperture and shutter, getting into the menu options lets you see how high-tech these cameras are and what additional options are available. The following list contains the menu settings I utilize on my Nikon D300S. For other camera systems, please refer to the index in your manual to see how these can be applied to your camera.

Playback Menu

Display Mode > Highlights/Data > check both. Having overexposed highlights flash when viewing an image is a quick way to gauge the exposure detail of the photo. I also like checking the shooting data and sometimes use this for reference when taking subsequent pictures.

Image review > Off. Personally I prefer not having the image pop up on the LCD every time I take a photo, so I turn this feature off and review images with the playback button.

Rotate tall > Off. Turning this off keeps an image in the same orientation as it was shot. Vertical images will be sideways when holding the camera horizontally, but it allows me to view an image in the same orientation it was shot at full-screen size. (If image review is left on, you may want to keep this feature turned on as well.)

ABOVE
Custom setting menu on a Nikon D300.

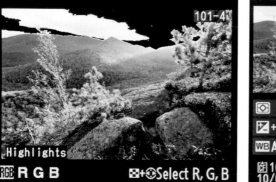

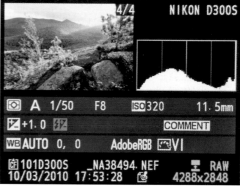

ABOVE

When "highlights" is turned on, any overexposed highlight areas flash in black.

ABOVE

The data screen showing all image specifications on the screen.

Shooting Menu

Image quality/File format: Except on rare occasions, I shoot at the highest quality uncompressed Raw file I can (14 bit). Some may choose to shoot both Raw and JPEG at once—or even just JPEG.

Image size: Changing the image size only affects JPEG capture. If shooting Raw/JPEG at once, you might only want a small JPEG file. However if only shooting in JPEG format, I suggest shooting at the largest size. It's easy to resize later.

JPEG compression: The best quality image setting creates the largest file, but provides the most information to work with later.

Raw bit depth: While 8-bit JPEG files have only 256 tonal variations per color per pixel (2 to the 8th power), 12-bit Raw files have 4096 variations, and 14-bit Raw files have 16,384. Since there are three color channels, each of these are multiplied to the power of three, so there are actually 16.7 million colors in an 8-bit JPEG file, and almost 4.4 trillion colors in a 14-bit Raw file. I shoot at the highest bit depth for the greatest options when processing images in an image-editing program.

White balance: Adjusting white balance can be helpful when shooting JPEGs—or used as a creative option, but for Raw capture I tend to leave this on automatic since it is easy to adjust color balance in an image-editing program.

Adobe RGB color space/sRGB: This setting applies to JPEG files. The Adobe color space has a larger color gamut, but it is perhaps best to stay with sRGB so the JPEG files are most compatible with other electronic devices. Raw files are given a color profile during the conversion process in an image-editing program.

Color Enhancement: Color enhancements generally only affect JPEG files. Set these to your personal preferences.

Highlights Enhancement (Active D): This is a Nikon in-camera process that drops the exposure slightly to capture highlight detail, and lightens the darker areas to help bring up shadow detail in contrasty lighting situations. This can result in some noise in the shadows. Personally I prefer to do all of this work in an image-editing program, where I can see the results, though this feature may be a benefit for JPEG images.

Long Exposure Noise Reduction: When this feature is turned on, the camera's processing time is the same length as the actual exposure time, so each exposure time is doubled. This feature compares the exposed image with another exposure taken with the shutter closed, comparing pixel noise from the "dark" file to the exposed one, and "cleans up" the final image file. This only affects exposures longer than about 8 seconds.

High ISO NR: While this feature does require some of the camera's memory buffer when shooting, the in-camera process helps clean up some of the noise in high ISO (over 800 ISO) images.

ISO 200 Raw ISO 200 JPEG ISO 6400 Raw ISO 6400 JPEG

ABOVE
All image comparisons are a 300% zoom from the same corner of an image file.
No color work has been done on any of the files the cropped samples came from.

ISO Sensitivity > Auto/Off: Since the cleanest and sharpest images come from the lower ISO settings, turning Auto ISO off lets you select the ISO for full image quality control.

LiveView mode/Tripod/Handheld: Tripod mode lets you select a focus point anywhere on the LCD screen, zoom into it with extreme detail and autofocus using a slower contrast detection method, or focus on the subject manually. Handheld mode uses the normal, faster phase detection autofocusing method—or manual focus—with much less magnification of the image on the LCD.

Multiple exposure: Multiple exposure offers a number of creative options. With Automatic Gain Control off, the exposures are additive, meaning it takes two ½ second exposures to equal the light in a 1 second exposure. With Automatic Gain Control on, the final image is a composite of information from the collection of normally exposed images.

Interval timer: An interval timer shoots a specific number of successive images at chosen intervals. This can be used in conjunction with the multiple exposure feature, or for other creative uses, including time-lapse photography.

Technique

Shooting

Creative Effects

Editing Workflow

Reference

Custom Setting Menu

Autofocus settings/Dynamic 3D 51 points: I generally use the broadest autofocus for most of my handheld photos, and work with manual focus for setting up tripod shots, but change this as needed for different situations.

Easy Exposure Compensation: This setting can be changed to adjust Exposure Compensation with a dial instead of having to also press the button.

Auto Meter/off delay > Infinity: Setting this to infinity holds the camera settings while waiting to take the photo. This change uses minimal power. This is especially important when doing multiple exposures with a considerable amount of time between each image.

Monitor off delay: It's best to minimize the length of time the monitor is on to a reasonable amount since the LCD is a large power drain.

Beep/Off: A quiet camera is best for wildlife—and sanity!

Viewfinder Grid Display: Having a grid display in the viewfinder and on the LCD helps for composition and the lining up of horizons and other subjects.

Viewfinder Warning Display > Low battery warning: I turn this feature on so I know right away if the battery power is running low.

Max Continuous Release > Set to the highest number: More often this is limited by the camera memory and speed of writing to the card, but I keep this set to the highest number available.

File Number Sequence > On: I number all of our images with a unique number. Since the numbering starts over again on my cameras after reaching 9,999, I change the initial extension for each 10,000 images.

Exposure Delay mode: This is a timed mirror lock-up feature that is helpful for any shooting situation—like long telephoto or macro shots—where mirror vibration could cause movement during an exposure.

Flash Shutter Speed setting: While I keep the flash sync speed set to the default highest automatic program speed, I do change the flash shutter speed sometimes. This sets the slowest shutter speed for flash operation. When doing occasional point-and-shoot type photos, I adjust this to a reasonable handheld shutter speed, set the camera to program mode and let it choose everything.

Flash control for built-in flash: The default "through the lens" or TTL setting offers the greatest flash accuracy, but there are times to use the other settings. For example, Manual Flash, Repeating Flash (to add additional flash bursts during an exposure), and Commander mode (for controlling additional remote flash units).

Multi-selector center button > Playback > View histograms: Pressing the center button gives a full-screen luminosity

EQUIPMENT

21

Technique

Shooting

Creative Effects

Editing Workflow

Reference

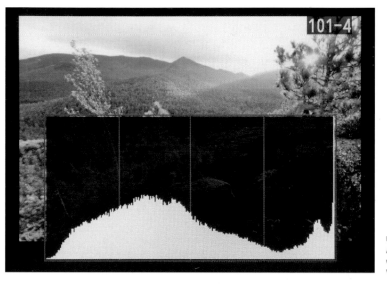

LEFT
A full-screen histogram option offers the clearest look at tonal values in an image

histogram when reviewing images on some cameras. I rely on this for scrutinizing histograms when reviewing images.

Assign AE-L > AF-L button > Button press > AE lock (Hold): Changing this setting to Hold keeps the exposure from fluctuating during a video sequence. It is an easy way to hold exposures through a panoramic sequence of still images.

Customize command dials > Menus and playback > On: When this setting is turned On, the command dial scrolls through images one by one when reviewing them.

No memory card > Lock: I always keep this setting on "lock" so I don't accidentally fire away without a card in the camera, expecting to see some great images.

Setup Menu

LCD Brightness > Normal: With the LCD set to normal the image brightness appears as intended. In bright conditions it's helpful to work with a covered loupe to view the screen.

Clean Image Sensor: I set mine so it does a sensor cleaning at each startup.

Video Mode: NTSC for US video/PAL in Europe.

Image Comment: Provides a place to add contact or other information within the metadata of each image file.

Auto Image Rotation > On: Embeds information so vertical images show up vertically on the computer screen.

Image Dust Off Reference Photo: Create a reference photo that is used in conjunction with special software to remove dust spots.

Battery Info: When maintained properly, the new Li-ion batteries can be used for years and recharged hundreds of times. Since there are no "memory" issues with them as there are with NiCd and NiMH batteries, it is best to recharge Li-ion batteries after partial discharge, only rarely using them until fully discharged. Also, avoid letting batteries get too hot.

Image Authentication: This is for software that verifies whether a photo file has been processed or edited after it was shot.

Copyright Info: Adding your name here embeds your copyright information in every shot taken.

Virtual Horizon: An LCD screen that shows if the camera is level.

Non CPU Lens Data: Add data for older non-CPU lenses.

Firmware Version: Check with the camera manufacturer periodically for firmware updates to keep the camera's operating system up to date.

My Menu

The personalized menu feature is a great way to put settings that are changed or referenced most often at your fingertips. My list includes: Exposure Delay mode, Flash Shutter Speed and Flash Control for built-in flash, LiveView controls, Long Exposure Noise Reduction, Movie settings, Multiple Exposure, Interval Timer, Raw settings, Virtual Horizon, and White Balance. A personalized menu feature is easily set up and useful for items that are harder to find among the other menus. There is an easy add/remove feature as well as a way to adjust the order of the entries. Some cameras have a reference for "recent settings." This is another easy way to refer back to settings you change frequently without having to search for them in all the different menus

Technique

Shooting

Creative Effects

Editing Workflow

Reference

Virtual horizon

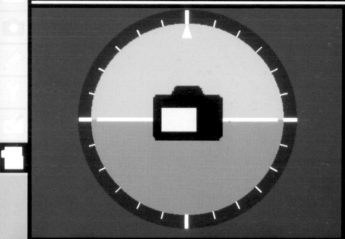

LEFT
The virtual horizon feature is a way to maintain a level horizon in both vertical and horizontal images.

Choosing Lenses and Focal Length

Interchangeable lenses for DSLRs range from ultra wide-angle fish-eye lenses with a 180-degree corner-to-corner field of view, to an 800mm super telephoto lens with only a 3.5 degree corner-to-corner field of view (with a full-frame sensor). The list also includes ultra-wide and wide-angle zooms, extended range zooms, telephoto zooms, macro lenses (close-up), tilt-shift perspective lenses, teleconverters, and extension tubes, each of which have the potential to impact your photography in a unique way.

A "normal" lens has a field of view that offers similar proportions to what the human eye sees. Since the focal length of a "normal" lens is approximately the same as the diagonal length of a sensor, it is different for each camera format and sensor size. While a 50mm focal length is considered normal for a full-frame 35mm camera, a 25mm focal length is normal for a Four Thirds format. Focal lengths shorter than normal are considered wide-angle lenses, and longer ones are considered telephoto lenses. Working with today's high-quality zoom lenses offers the greatest flexibility in the field with many more options for composition at your fingertips.

There are two things to consider when deciding what focal length to use. First, is the overall field of view—how much of the surrounding scene you want to include in an image. The second is depth of field—which relates to the distance that is in apparent focus in front of, and behind, the main subject. Depth of field is directly related to focal length, and it doesn't matter whether you work with a zoom lens or a fixed focal length lens, or different size sensors.

The widest angle lenses with the greatest field of view offer the greatest depth of field, while lenses with the smallest field of view (telephoto or macro) have the most shallow depth of field. Wide-angle lenses offer a way to integrate the whole story, while telephoto and macro lenses portray the details within. Faster lenses—with larger maximum apertures (f/2.8 or larger) are best for low-light photography, sports, and wildlife, while good quality slower lenses (f/3.5 or smaller) can still work well for digital landscape photography since most landscape photography is shot with an aperture of f/8 or smaller.

Because smaller sensors "crop" the field of view of any given focal length lens, there is a magnification factor to consider when comparing the field of view of a lens used with smaller sensors to what we are used to seeing with a full-frame sensor (same size as 35mm film). Since a Four Thirds format sensor is about half the height and width of a full-frame sensor, there is a 2× magnification. So, a 105mm lens used on a Four Thirds sensor has the same field of view as a 210mm lens on a full-frame sensor. This also means that in order to achieve the wide field of view of a 20mm lens on a full-frame camera, you need to use a 10mm lens on a Four Thirds camera. The most common conversion factors for the different APS size sensors are 1.5× and 1.6×.

ZOOM AND FOCAL LENGTH

These image comparisons offer two different ways to think about working with lenses. They each show comparisons between lenses used on an APC sensor (1.5×) with a 135mm focal length, a normal focal length (40mm) and an ultra-wide focal length (11mm). The photos in the top row were all taken from exactly the same location. In the lower row, I changed the camera distance from the snowshoes, trying to keep the snowshoes at the same relative size in the image with each of the different focal lengths. Note how both the background, and depth of field changes in relation to the snowshoes and fence from the 11mm shot to the 135mm shot. All images were shot focused on the snowshoes.

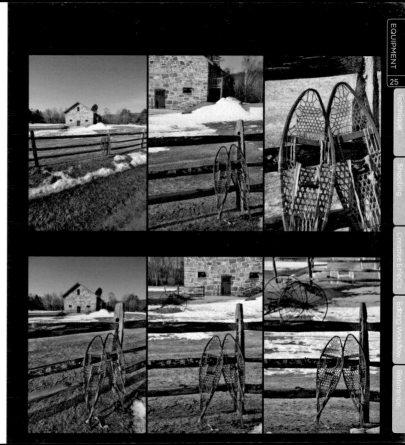

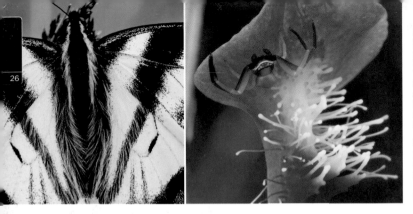

Tips for Choosing Lenses

- Quality lenses with the highest level of sharpness and clarity offer the best image quality.
- Stabilization features are especially helpful for freehand shooting with telephoto lenses.
- Two well chosen zooms for any of the DSLR sensor formats can provide a focal length range from about 16mm–300mm (full-frame equivalent), and cover an extensive range of options for outdoor and landscape photography.
- Having a lens with focal distance settings on the barrel is easier for working with depth of field.
- A set of extension tubes turns most any lens into a macro lens and is an easy way to begin experimenting with close-up photography. Extension tubes work well with zooms, and separate units can be combined for greater magnification with less depth of field. The longer the focal length, the longer the extension tube.
- A teleconverter offers greater magnification of an image through a telephoto lens. Image quality though is only as good as the quality of the original lens, since the teleconverter simply magnifies the image coming through the main lens.
- Tilt-shift lenses offer ways to straighten architectural and natural landscapes, and work with depth of field. They are limited though to specific focal lengths and compositions.
- With fish-eye lenses, straight lines curve around a central point, offering some unique perspectives for composition.
- Lensbaby style lenses offer different selective focus/depth-of-field shooting options.

EQUIPMENT

27

Technique

Shooting

Creative Effects

Editing Workflow

Reference

TOP LEFT

The broad field of view of ultra wide-angle lenses encompasses many details within an image. 11.5mm (APS), ISO 200, 2.5 sec at ƒ/10.

CENTER LEFT

Fish-eye lenses have about a 180-degree corner-to-corner field of view, and lines all curve around the central point. This provides some fun creative opportunities. 16mm fish-eye (Full); ISO 100; 1/50 sec at ƒ/22.

BELOW LEFT

With a "normal" focal length lens, objects in a photograph appear in about the same perspective as that seen by the human eye. 34 mm (APS); ISO 250; 1/160 sec at ƒ/16.

ABOVE

A long focal length telephoto lens is best for isolating details in a view. 200mm (APS); 1/3; ƒ/0; ISO 200.

Tripod and Cable Release

I don't just recommend using a tripod, I feel it is essential for many different landscape photography situations. While stabilized lenses and the high quality image files of today's digital cameras offer more flexibility for hand-holding the camera, using a tripod is essential for low-light photography and maximizing depth of field. It's also a great way to set up and fine-tune composition, and is the best way to obtain a bracketed set of images for HDR work.

While a tripod definitely needs to be sturdy, having one that easily adjusts to an infinite range of shooting angles from eye height or taller, right down to ground level, makes the difference between having a tripod that gets used regularly, and one that collects dust in the corner. My favorite tripod has an articulating center column that quickly adjusts to any angle from vertical to horizontal to upside down by just turning a knob. The four-section carbon-fiber legs lock easily and offer good extended height, as well as a more compact size for backpacking.

While there are several different styles of camera heads, a well designed ballhead is a good choice for landscape photography. Choose one with a rotating base that offers easy adjustment from horizontal to vertical orientation, and also works well when at unusual angles, such as an offset ballhead that firmly locks the camera in position and has full flexibility whether right side up, sideways, or upside down. One option for a camera mount is an "L" bracket that allows changing the camera position from vertical to horizontal without readjusting the head and tripod. Another option is a clamp head, which

ABOVE
Tripod use is essential for photographing the soft effect of water in motion. 24mm (Full); ISO 100; 1 sec at f/16.

can be placed anywhere along a cylindrical tripod leg and offers additional shooting options.

A cable release or wireless remote provides the best shutter control when the camera is mounted on a tripod. The remote should be able to trigger the shutter, as well as lock the shutter open for extended "bulb" exposures that are longer than the maximum shutter speed on the camera. Some manufacturers offer extensive control with certain models of remotes, including multiple exposure and interval timer features.

EQUIPMENT

29

Technique

Shooting

Creative Effects

Editing Workflow

Reference

ABOVE, LEFT TO RIGHT

A tripod for landscape photography needs to be versatile enough for working from ground level to standing height easily. Here is the Gitzo Explorer four section tripod.

This is an image shot with the camera/tripod in the previous photo. Tripods are helpful when refining composition, as well as for shooting tack-sharp images when using the slower shutter speeds and small apertures needed for maximizing the depth of field.

Using a clamp head on the tripod leg with a cable release allows the camera to be placed in some unique positions. LiveView lets you compose from a distance.

Tripod Selection

- Cost is generally relative to weight, strength, and features.
- Four-section legs are slightly heavier, but create a shorter package for carrying.
- Carbon fiber is the lightest, strongest material for tripod legs.
- Tripod legs should move and lock independently—and not be attached to a center column.
- Legs should be able to spread out parallel to the ground for ground-level shooting.
- Interchangeable tripod feet can offer use of spikes, snow plates, or rubber tips.
- A hook on the end of the center column provides a place to hang a weighted bag. This extra weight helps stabilize the tripod in windy conditions.
- Look for a moisture- and rust-resistant leg locking system.

Tripod Heads

- Proportionately larger balls on a ballhead are more easily locked into position and hold heavier cameras with large telephoto lenses more securely.
- Standardized quick-release plates help make it easier to quickly swap camera equipment.

Tripod Tips

- Extend the lowest legs first to help keep the leg locks out of sand, dirt, and water.
- Rinse everything thoroughly with fresh water after use around saltwater.
- Turn off lens stabilization when a camera is on a tripod to avoid image softness that can occur as a lens tries to lock in on a subject.
- Use mirror lock-up or Exposure Delay mode for exposures with a telephoto or macro lens.

Filters, Flash, and Accessories

The most common filters used for landscape photography are: UV or skylight, ND (neutral density), graduated split ND, and polarizing filters. I typically keep a clear UV or skylight filter on the front of my lenses to help protect the lens itself. It's much easier to replace a scratched UV filter than a lens! Special filter holders that use adapters for various size lenses offer the most options for shooting with filters (Cokin "P" and Lee are some of the most popular). Filters can also be purchased for each different lens diameter.

Split ND filters that can be adjusted as needed within a rotating filter holder, are the best way to even the tonal contrast between a bright sky and the landscape, such as in a sunrise or sunset, or a beach or snow scene. Solid toned NDs, like a 6 stop ND, or variable ND filter, provide a way to play with longer exposure time for special creative effects while shooting. The best ND filters are glass and have no perceptible color tone at all.

Enhancing filters can be used to improve your image in the field, or do some creative experimentation. A polarizer helps reduce reflections and stray light, enhancing contrasts and colors on JPEG files, and making it easier for post-processing Raw files. Diffusion filters add a soft dreamy effect. In addition there are also color intensifiers, warming filters, variable gold and blue, infrared, black-and-white photography filters, and many other color toned and special effects type filters.

Since film is designed for specific tonal ranges of light and has a relatively low dynamic range, it is often necessary to use filters to achieve a balanced and pleasing tonal effect for the final image. With digital cameras though, most filter effects can be recreated more cleanly with an image-editing program. It's easy to adjust white balance and color saturation in the camera for JPEGs, or in post-processing for Raw files.

BELOW
An assortment of different accessories.

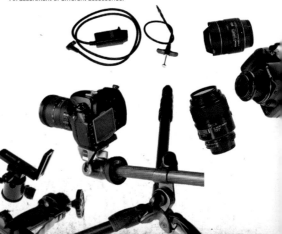

EQUIPMENT

31

Technique

Shooting

Creative Effects

Editing Workflow

Reference

BELOW
Handheld light meter.

CENTER TOP
A Cokin "P" filter holder and a couple of lens adapter rings.

CENTER BOTTOM
A pair of graduated split ND filters—one a hard step, the other a soft step.

BELOW
A filter can be slid up and down in the filter holder for precise placement.

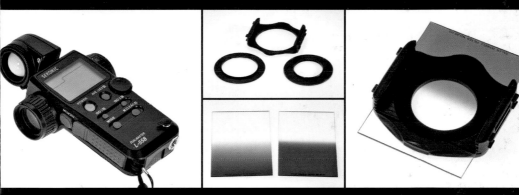

Filter Options

- UV or Skylight (lens protection)
- Polarizer (for cutting glare and reflections)
- Split graduated ND (neutral density)
- Full ND/Vari-ND (add exposure time)
- Color intensifier
- Diffusion (soft focus)

- Fog effect
- Special effects (flare, star effect, multi-image)
- Tonal adjustment (warming, black/white filters)
- Infrared
- Close-up diopters (for close-up/macro)
- Cokin "P"/Lee holder system

BELOW, LEFT TO RIGHT

| An electronic cable release on the left, and a manual one on the right. | With an "L" bracket mount, the camera orientation can easily be changed from horizontal to vertical. | A ballhead mount provides a lot of flexibility. The larger the ball, the more fluid and secure it is. | An inflatable "softbox" flash reflector/ diffuser offers a lightweight and compact package for enhancing images needing some fill-flash. |

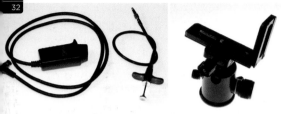

In addition to the essential tripod and cable release, there are many different accessories that can be used to enhance landscape photographs. Flash units and reflectors can be used to highlight subjects in landscapes for special lighting effects. For the few times I use a flash with my images, the built-in strobe on my camera is sufficient, though advantages of off-camera flash include an independent power supply and the ability to choose light direction. Flashlights and headlamps can also be used to "paint in" subtle artificial lighting on specific subjects after the sun goes down.

A hoodloupe helps magnify the image on the LCD screen, plus it blocks out stray light for easier viewing in bright conditions. Using a right-angle viewfinder with the eyepiece helps when composing an image with the camera close to the ground. While the camera light metering system is sufficient for most any landscape photography, there are times when a handheld light meter can be useful, as it offers metering for both reflective and incident light.

Since wet, misty weather is great for moody, artsy images, it's good to carry along a rain cover for the camera. This can be a commercially made cover, a plastic bag with a hole cut in the end for the lens, or a wide-brimmed waterproof hat. Another option is using a flexible arm with clamps on both ends that can hold an umbrella or a reflector above the tripod. This offers protection in calm conditions for both the camera and photographer.

Additional accessory possibilities include waterproof camera cases for underwater photography, and equatorial mounts that track star movement for astrophotography. Underwater camera cases range from inexpensive vinyl bags to specially manufactured cases that can be more expensive than a camera. It's a similar case for equatorial mounts—some of the least expensive ones don't necessarily get great reviews. One relatively inexpensive option is a wind-up MusicBox EQ mount. Another option is a program like Deep Sky Stacker that will combine a sequence of star landscape images into either star points, or trails.

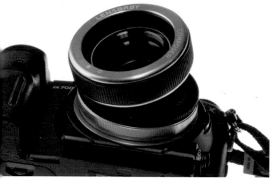

TOP AND BOTTOM
Lensbaby offers a number of unique lens
options for creative landscape photography.

Be sure to keep a couple of extra batteries and memory cards in your camera bag. Nothing is more frustrating than trying to squeeze the last mini-volts from a battery, or deleting extra images to make more room on a card, while the light is dancing on the landscape! After the shoot, a portable hard drive/viewer and/or laptop gives a place to store and edit images shot during the day.

While self-cleaning sensor technology was a milestone in reducing digital image dust spots, there are still times when it is helpful to have an air blower for cleaning clingy dust off the sensor. More extensive sensor cleaning kits are available, but research them thoroughly to be sure they will be helpful for your equipment and won't harm the sensor in any way.

Accessory Options:

- Tripod
- Remote cable release
- Flash unit(s)
- Hood loupe (LCD viewer)
- Right-angle viewer
- Portable reflectors
- Flexible clamp holding system
- Camera rain cover
- Umbrella (windproof)
- Flashlight (headlamp)
- Light meter
- Air blower for sensor cleaning
- Sensor cleaning kit
- Extra batteries
- Extra memory cards
- Portable hard drive
- Laptop
- Underwater case
- EQ (equatorial) system for starscapes

Outdoor Gear and Safety

LEFT

When choosing a camera pack, consider how much hiking gear you need to carry in addition to your camera gear.

RIGHT

My LowePro Orion AW camera pack features a rucksack top that can be quickly removed from the camera bag on the bottom. Photo by Dr. William Brown.

There's a camera pack for every aspect of photography today, from small individual cases for point-and-shoot models, to slings, backpacks, and waterproof/shock resistant cases for traveling. When choosing a bag, give careful thought to everything you want to carry—outdoor gear as well as camera gear—so there is enough room and compartments to hold everything you need.

At home, I use several different packs to house my various equipment, and then I typically choose from one of two bag systems when I head out to shoot. For easy-access lightweight travel, I use a single camera pouch that will house a DSLR with either an 18–200, or 11–16 zoom, plus carry the unused zoom in a pouch on the bag. Since I am often hiking to get to a photo location, for extensive photo shoots I choose my two-part modular backpack that combines an upper detachable rucksack, with a lower camera bag that will hold two DSLRs and lenses. The combined system can be used as a backpack, and the camera compartment becomes a shoulder bag when the rucksack is replaced with a shoulder strap.

Today's clothing and outerwear provides a way for everyone to stay comfortable in all kinds of weather. It's been many years since I wore layers of wool to stay comfortable in mountain conditions. A combination of windproof/waterproof/breathable parkas and pants over layers of synthetic clothing for comfort and insulation keep me comfortable and dry in all kinds of weather. I find layers of all synthetic materials work best in all outdoor conditions—both hot and cold. Cotton should be avoided as a material for any layers, since once it becomes wet from weather or perspiration, it takes an excessive amount of time to dry, contributing to potential hypothermia issues. Dress to stay dry! Add layers as you cool down, and remove them as you begin to warm up again.

EQUIPMENT

35

Technique

Shooting

Creative Effects

Editing Workflow

Reference

Cold weather can be a concern for camera equipment. It's okay to take a warm camera into the cold, but be sure to protect a cold camera when bringing it into a warm space. Condensation can form both inside and outside the camera, killing the electronics if it gets too wet inside. Place a camera inside a plastic bag or in a camera bag before going into the warmer air, and let it warm up to room temperature before exposing it to the air.

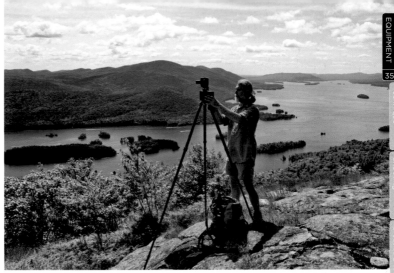

Backcountry Safety:

- Wear layers of synthetics and a waterproof/breathable shell for four-season comfort.
- Depending on the season, layers may include long johns, trousers, shirt, fleece layers, parka, gloves, mittens, hat, face mask or balaclava, and footwear.
- Nylon gaiters protect lower legs and boots from snow, debris, and insects.
- Thin liner gloves are helpful for handling camera gear in cold conditions.

- A wide-brimmed and waterproof/breathable hat protects from the sun, rain, snow, and bugs, and can also double as an all-weather cover for a camera.
- In the backcountry, hike in minimum groups of four for safety.
- Backcountry safety gear includes a sleeping bag, foam pad, bivouac sack, stove, small pot, headlamp, map and compass, whistle, short section of rope, pocketknife, extra food and water, plus some extra clothes.
- Staying hydrated and dry helps prevent hypothermia and heat exhaustion.
- Avoid using cotton for any layers.

Finding the Best Locations

Finding the right location to photograph is a major part of being "in the right place at the right time." When you know an area, it's much easier to put yourself in the right place, but for new locations, it's more difficult to figure out where to be and when. I still prefer the broad perspective of a topo map as a guide to regional trails and finding great backcountry viewpoints with wonderful photo opportunities. They are quite helpful for visualizing the landscape and contours (concave lines on a mountain are valleys, and convex curved lines are ridges, lines packed tightly together are open rock faces or cliffs). On the Internet, Google Maps has an option (More/Terrain) which adds shaded relief and topo lines for a location. Using a handheld topo map in conjunction with a modern GPS (global positioning system) device is the optimal way to travel, since you can easily pinpoint your location with the GPS, plus have the broader perspective of the map.

GPS devices pinpoint your location and elevation within a few feet by triangulating your location in relation to satellites in a stationary orbit. A GPS can be used for getting to new locations, or for tracking your way back to places you've been before—as long as your GPS can read the signals from a minimum of four different satellites. With some cameras, an integrated GPS adds location coordinates to the metadata of your digital image files, making for easy geotagging and labeling. In the field, it's always good to have both a map and compass in addition to the GPS in case of battery failure, or loss of satellite signals. A GPS can also be coordinated with locations on Google Earth, which maintains a visual record of photo locations. Google Earth can also be used to sample the view and check out shooting locations by zooming in to ground level. It can be set up with the time of day to show shadows on the landscape, as well as the exact place the sun will be rising or setting in relation to any specific location, and current local weather conditions can be added as well!

While Google Earth can portray sunrise and sunset locations, currently it does not show the location of the moon. Since the lunar orbit has a pronounced wobble, the rise and set location on the horizon compared to due east or west can vary considerably from one month to another. By checking the azimuth (degrees based on a compass heading) for the rise or set times in a lunar software program, it's then easy to approximate the view in Google Earth where the moon will appear above the horizon in relation to any given point on Earth.

The Internet is indispensable for finding information when traveling to new locations. Research regional tourism sites, and look for photography and hiking guidebooks, maps and brochures. I generally check for nature reserves, wildlife refuges, gardens, private natural sites, public access sites, and national, state or provincial parks. Park rangers, natural history museums, and interpretive centers can often provide tips on locations to photograph. You might also contact local guides, and regional mountain and hiking clubs. Remember to check on the timing of annual natural events—flower blooms, wildlife migrations, fall colors, and any related organized activities.

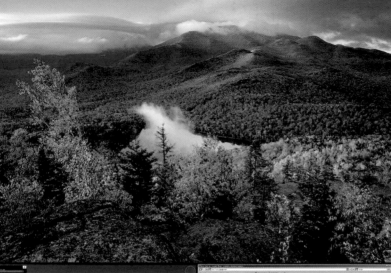

LEFT

While Google Earth gives a sense of the view, being there in the right light and weather conditions lets you get that unique shot. Adirondack Park, NY. 24mm (Full); ISO 100; 1/2 sec at f/11.

BELOW LEFT

In Google Earth, use the slider "+" control to zoom into ground level for a 3D perspective, and pan around the view using the compass tool. Adjust the controls on the toolbar to simulate sunrise, set, and shadows across the landscape.

BELOW RIGHT

Google Maps offers an online map option with shaded relief and topographical lines for any location in the world by checking "More/Terrain."

©2010 Europe Technologies ©2010 Google Image USDA Farm Service Agency ©USFWS (far left)

©2010 Google—Map data ©2010 Google (left)

TECHNIQUE

Owning a vast array of camera equipment may offer lots of options for shooting, but understanding the basic principles involved and being able to apply them with different focal length lenses is the key to being in control of each photograph. Firing away with the camera in Program mode provides a good chance for having a few nice keepers. However, knowing how to utilize the principles of the aperture and shutter lets a photographer create photos by choice, rather than chance.

There are four basic camera features that control each exposure—the aperture, shutter, ISO setting, and Exposure Compensation. Each affects the photograph in a different way. The aperture diameter determines the amount of depth of field, the shutter speed controls how motion is portrayed, the ISO setting affects image quality, and Exposure Compensation fine-tunes each exposure. Aperture Priority and Shutter Priority modes let me quickly choose the parameters I need to change regarding depth of field and motion, while the camera automatically meters the light. I then adjust the exposure for various lighting conditions using Exposure Compensation and the ISO setting.

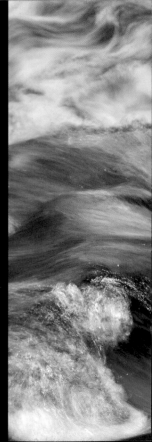

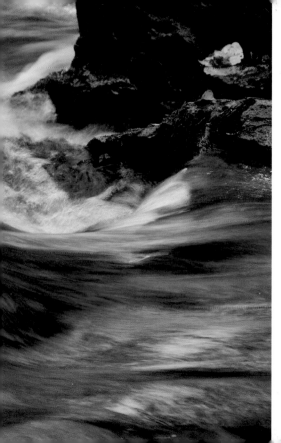

Equipment

TECHNIQUE

39

Shooting

Creative Effects

Editing Workflow

Reference

For situations where depth of field is most important, I use Aperture Priority mode and the camera's multi-segment metering. When controlling motion is most important, I work with Shutter Priority mode. I choose the shutter speed and the camera selects the appropriate aperture. Since depth of field is most important for many of my landscape images, I use Aperture Priority mode most of the time, Shutter Priority sometimes, and Manual mode only for long nighttime exposures.

While both the aperture and shutter adjust the amount of light coming through the lens, the ISO setting adjusts the sensitivity of the sensor to light. By adjusting the ISO, specific aperture/shutter speed combinations can be used in varying intensities of light. Camera light meters are designed to balance the tonal values of each exposure to an 18% gray value. Exposure Compensation provides a way to override the camera and select the optimal exposure in scenes where the overall tonal values are either darker or brighter than 18% gray.

LEFT

For this image I needed to control aperture, shutter speed, ISO, and also work with Exposure Compensation. The 105mm focal length required a small enough aperture to give depth of field from the water in the foreground to the furthest edge of the rock, and shutter speed had to be slow enough to show water motion, but fast enough that the reflected highlight colors weren't lost in a blur. I used Shutter Priority mode to hold the shutter speed for the water detail I wanted, adjusted the aperture for the necessary depth of field, raised the ISO to maintain both the shutter speed and aperture needed in the available light, then set Exposure Compensation to overexpose by 1/3 stop to compensate for the brighter tonal balance in the scene. 105mm (APS); ISO 400; 1/6 sec at ƒ/11.

Aperture and Depth of Field

The aperture is a diaphragm in the lens consisting of a set of blades that adjusts the diameter of the opening to vary the amount of light passing through the lens. This adjustment is measured by f-stops ($f/2$, $f/2.8$, $f/4$, $f/5.6$, $f/8$, $f/11$, $f/16$, $f/22$, $f/32$), which are the denominators of fractions that are the ratio of the focal length to the effective aperture diameter. Each full f-stop either doubles or halves the amount of light passing through the lens. More important though is that the size of the aperture opening also determines the amount of depth of field.

The potential amount of depth of field is directly related to the focal length being used—it is not related to sensor size. The shorter the focal length of the lens, the greater the depth of field available. The amount of depth of field for any given focal length is the same for both a fixed focal length prime lens, and a focal length setting on a zoom lens. With the lens set at its largest aperture opening, whatever distance the lens is focused on will be in sharp focus, everything in front of and behind that plane of focus will have varying levels of softness.

OPPOSITE RIGHT

The widest angle lenses (shortest focal length) have the greatest depth of field. Using a 10mm focal length, this image has depth of field from three inches to infinity. 10mm (APS); ISO 200; 1/ 250 sec at $f/22$.

RIGHT

A telephoto lens is great for isolating particular details because of its shallow depth of field. 170mm (Full); ISO 100; 1/400 sec at $f/8$.

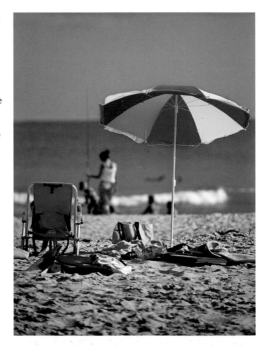

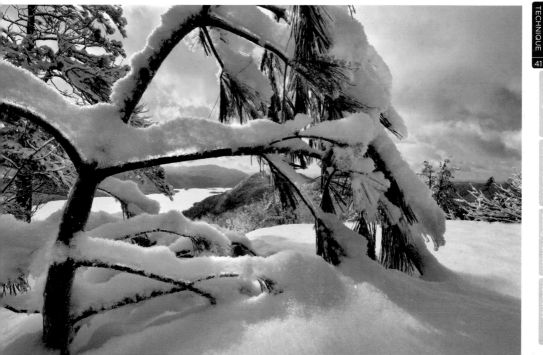

Equipment

TECHNIQUE

41

Shooting

Creative Effects

Editing Workflow

Reference

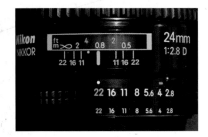

TOP LEFT

To work with the hyperfocal settings on a lens, place the furthest point of focus desired at the aperture setting being used on the left. The nearest point that will appear in focus at that aperture setting is on the right. At the $f/22$ setting on this 24mm lens, when the actual focus point is set to 3 feet, there is apparent depth of field from 1.5 feet to infinity.

With the lens at its smallest aperture, there is less diffusion of the light rays falling on the sensor, so there is greater apparent sharpness in front of and behind the plane of focus.

Learning how to work with hyperfocal settings dramatically changed how I approached my landscape compositions. Working with small apertures along with hyperfocal settings provides the potential to place main subjects closer to the lens, and create more dynamic compositions.

When photographing with fixed focal length lenses, I often focused my images using the hyperfocal settings on the lens. With the lens set to a small aperture and focused on infinity, there is greater depth of field in the image closer to the camera, but the depth of field potential beyond that plane of

$f/22$ (70-200 $f/2.8$ ZOOM LENS)

At the smallest aperture setting with this zoom at 200mm, and focused at the center thickness of the milkweed pod, all detail around the pod is in focus, and the background is sharp enough to be a distraction.

Equipment

TECHNIQUE

43

Shooting

Creative Effects

Editing Workflow

Reference

f/8 (70-200 f/2.8 ZOOM LENS)

Focused on the middle of the pod with a mid-size aperture allows the entire pod to be in sharp focus from front to back, and the background is soft enough so it doesn't conflict as much with the pod detail.

f/2.8 (70-200 f/2.8 ZOOM LENS)

At the largest aperture opening for this zoom at 200mm, the background detail is nice and soft, but the very shallow depth of field only allows a narrow plane of sharp focus so both the foreground and background "puffs" of the milkweed pod are out of focus and too soft.

focus is lost. By placing infinity on the aperture setting being used, the similar aperture setting on the opposite side shows the nearest point of apparent focus. The exact point of focus in the center is the hyperfocus point.

The chart provides a way to set up hyperfocal settings with different focal lengths. All the settings on the chart use infinity as the furthest point of focus. If your lens has a reference for focusing distances, you can set your hyperfocus point there. With no distance or hyperfocal settings on the lens, focus on an object at the required distance on the chart for the hyperfocus point for the chosen aperture settings and focal length.

Working with a lens at small aperture settings can cause slight image softness from the diffraction of light on aperture blade edges. The amount of softness will vary with different lenses. I work with high-quality lenses, and have really had no issues over the years with using $f/22$ for many of my images.

Depth of Field Tips

o When working to control depth of field, shoot in Aperture Priority mode. Set the aperture and the camera will adjust the shutter speed for the best exposure.
o The shorter the focal length of the lens, the greater the depth of field.
o The amount of depth of field is specific to the focal length of the lens, no matter what format camera the lens is being used with.

To find the hyperfocus point for any image:
o Focus on the closest subject and note that distance setting on the lens barrel.
o Then focus on the farthest subject and note that distance.
o Set your actual point of focus on the lens barrel midway between the near and far focus points.
o Take the shot and play it back on the LCD.
o Zoom in to see if edge detail has similar sharpness throughout the image from the nearest subject to the farthest subject.
o If a near or far subject is in focus and the other is not, adjust your hyperfocus point to the out-of-focus subject.
o If both are not in focus, use a smaller aperture setting.
o If you are at the smallest aperture and both are still not in focus, your composition has exceeded the depth of field capability for that focal length.

If the depth of field desired is greater than is physically possible with that focal length lens, there are two options:
o Work with a shorter focal length and recompose.
o Or take a set of images focused at different points throughout the subject range that can be composited with a program like Photoshop or Helicon Focus to digitally extend the depth of field.

Hyperfocal Distance Chart

The grid below assumes a depth of field that extends from the nearest possible point of focus to infinity.

NF is the near focal point (the nearest point that will appear in focus).

HF is the hyperfocus point—the actual distance you need to focus on to achieve a depth of field that covers the near point of focus all the way to infinity at the specific aperture setting.

		f/1.4		f/2		f/2.8		f/4		f/5.6		f/8		f/11		f/16		f/22		f/32	
		Ft & In	Meters	Ft & In	Meters	Ft & In	Meters	Ft & In	Meters	Ft & In	Meters	Ft & In	Meters	Ft & In	Meters	Ft & In	Meters	Ft & In	Meters	Ft & In	Meters
10mm	HF	8' 3"	2.53	5' 10"	1.79	4' 2"	1.26	2' 11"	0.89	2' 1"	0.63	1' 6"	0.45	1' 0"	0.32	0' 9"	0.22	0' 6"	0.16	0' 4"	0.11
	NF	4' 2"	1.26	2' 11"	0.89	2' 1"	0.63	1' 6"	0.45	1' 0"	0.32	0' 9"	0.22	0' 6"	0.16	0' 4"	0.11	0' 3"	0.08	0' 2"	0.06
12mm	HF	11' 11"	3.64	8' 5"	2.57	6' 0"	1.82	4' 3"	1.29	3' 0"	0.91	2' 1"	0.64	1' 6"	0.45	1' 1"	0.32	0' 9"	0.23	0' 6"	0.16
	NF	6' 0"	1.82	4' 3"	1.29	3' 0"	0.91	2' 1"	0.64	1' 6"	0.45	1' 1"	0.32	0' 9"	0.23	0' 6"	0.16	0' 4"	0.11	0' 3"	0.08
14mm	HF	16' 3"	4.95	11' 6"	3.50	8' 1"	2.48	5' 9"	1.75	4' 1"	1.24	2' 10"	0.88	2' 0"	0.62	1' 5"	0.44	1' 0"	0.31	0' 9"	0.22
	NF	8' 1"	2.48	5' 9"	1.75	4' 1"	1.24	2' 10"	0.88	2' 0"	0.62	1' 5"	0.44	1' 0"	0.31	0' 9"	0.22	0' 6"	0.15	0' 4"	0.11
16mm	HF	21' 3"	6.47	15' 0"	4.57	10' 7"	3.23	7' 6"	2.29	5' 4"	1.62	3' 9"	1.14	2' 8"	0.81	1' 10"	0.57	1' 4"	0.40	0' 11"	0.29
	NF	10' 7"	3.23	7' 6"	2.29	5' 4"	1.62	3' 9"	1.14	2' 8"	0.81	1' 10"	0.57	1' 4"	0.40	0' 11"	0.29	0' 8"	0.20	0' 6"	0.14
18mm	HF	26' 10"	8.18	19' 0"	5.79	13' 5"	4.09	9' 6"	2.89	6' 9"	2.05	4' 9"	1.45	3' 4"	1.02	2' 4"	0.72	1' 8"	0.51	1' 2"	0.36
	NF	13' 5"	4.09	9' 6"	2.89	6' 9"	2.05	4' 9"	1.45	3' 4"	1.02	2' 4"	0.72	1' 8"	0.51	1' 2"	0.36	0' 10"	0.26	0' 7"	0.18
20mm	HF	33' 2"	10.1	23' 5"	7.14	16' 7"	5.05	11' 9"	3.57	8' 3"	2.53	5' 10"	1.79	4' 2"	1.26	2' 11"	0.89	2' 1"	0.63	1' 6"	0.45
	NF	16' 7"	5.05	11' 9"	3.57	8' 3"	2.53	5' 10"	1.79	4' 2"	1.26	2' 11"	0.89	2' 1"	0.63	1' 6"	0.45	1' 0"	0.32	0' 9"	0.22
24mm	HF	47' 9"	14.6	33' 9"	10.3	23' 10"	7.27	16' 10"	5.14	11' 11"	3.64	8' 5"	2.57	6' 0"	1.82	4' 3"	1.29	3' 0"	0.91	2' 1"	0.64
	NF	23' 10"	7.27	16' 10"	5.14	11' 11"	3.64	8' 5"	2.57	6' 0"	1.82	4' 3"	1.29	3' 0"	0.91	2' 1"	0.64	1' 6"	0.45	1' 1"	0.32
28mm	HF	65' 0"	19.8	45' 11"	14.0	32' 6"	9.90	23' 0"	7.00	16' 3"	4.95	11' 6"	3.50	8' 1"	2.47	5' 9"	1.75	4' 1"	1.24	2' 10"	0.88
	NF	32' 6"	9.90	23' 0"	7.00	16' 3"	4.95	11' 6"	3.50	8' 1"	2.47	5' 9"	1.75	4' 1"	1.24	2' 10"	0.88	2' 0"	0.62	1' 5"	0.44
35mm	HF	101'	30.9	71' 9"	21.9	50' 9"	15.5	35' 11"	10.9	25' 4"	7.73	17' 11"	5.47	12' 8"	3.07	9' 0"	2.73	6' 4"	1.93	4' 6"	1.37
	NF	50' 9"	15.5	35' 11"	10.9	25' 5"	7.74	17' 11"	5.47	12' 8"	3.87	9' 0"	2.73	6' 4"	1.93	4' 6"	1.37	3' 2"	0.97	2' 3"	0.68
50mm	HF	207'	63.1	146'	44.6	103'	31.6	73' 3"	22.3	51' 9"	15.8	36' 7"	11.2	25' 11"	7.89	18' 4"	5.58	12' 11"	3.95	9' 2"	2.79
	NF	103'	31.6	73' 3"	22.3	51' 9"	15.8	36' 7"	11.2	25' 11"	7.89	18' 4"	5.58	12' 11"	3.95	9' 2"	2.79	6' 6"	1.97	4' 7"	1.40
72mm	HF	429'	131	303'	92.6	214'	65.5	151'	46.3	107'	32.7	75' 11"	23.1	53' 8"	16.4	38' 0"	11.6	26' 10"	8.18	19' 0"	5.79
	NF	214'	65.5	151'	46.3	107'	32.7	75' 11"	23.1	53' 8"	16.4	38' 0"	11.6	26' 10"	8.18	19' 0"	5.79	13' 5"	4.09	9' 6"	2.89
105mm	HF	913'	278	645'	197	456'	139	322'	98.4	228'	69.6	161'	49.2	114'	34.8	80' 9"	24.6	57' 1"	17.4	40' 4"	12.3
	NF	456'	139	322'	98.4	228'	69.6	161'	49.2	114'	34.8	80' 9"	24.6	57' 1"	17.4	40' 4"	12.3	28' 7"	8.70	20' 2"	6.15
150mm	HF	1864'	568	1318'	402	932'	284	659'	201	466'	142	329'	100	233'	71.0	164'	50.2	116'	35.5	82' 5"	25.1
	NF	932'	284	659'	201	466'	142	329'	100	233'	71.0	164'	50.2	116'	35.5	82' 5"	25.1	58' 3"	17.8	41' 2"	12.6
200mm	HF	3314'	1,010	2343'	714	1657'	505	1171'	357	828'	253	585'	179	414'	126	292'	89.3	207'	63.1	146'	44.6
	NF	1657'	505	1171'	357	828'	253	585'	179	414'	126	292'	89.3	207'	63.1	146'	44.6	103'	31.6	73' 3"	22.3

Shutter and Motion

There are only two physical adjustments that can be made with every shot you take. While the size of the aperture opening regulates the amount of light passing through the lens, the camera's shutter speed controls the amount of light reaching a digital sensor by varying the length of time the sensor is exposed to the light.

This process can be looked at in two ways. First, the shutter speed adjustment regulates the amount of light needed to properly expose the photograph. Second, and more important in many situations, is the fact that the length of the exposure also determines how motion is portrayed in a photograph.

The easiest way to control shutter speed is with Shutter Priority mode, where you set the shutter speed and the camera selects a corresponding aperture.

A general rule of thumb for hand-holding the camera and lens to take

an acceptably sharp image is choosing a shutter speed that is at least 1/focal length. Today's stabilizing features make it possible to shoot at shutter speeds that range from 2 stops, to as many as 4 or 5 stops less than the recommended hand-holding speeds. However, those reduced shutter speeds may not be fast enough to eliminate motion blur in a subject. It is also helpful to think of shutter speed in relation to the effective focal length. For example, an 85mm lens on a 1.5× sensor camera has an effective focal length of 135mm, so the shutter speed should be at least 1/135 second.

RIGHT
There was just enough light to use a faster shutter speed of 1/100, along with a small aperture (f/16), to maintain both depth of field and the ripple detail in the water. I also used a low ISO (250) for a sharp, clean image.

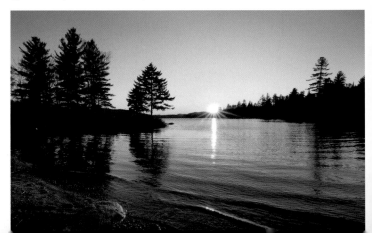

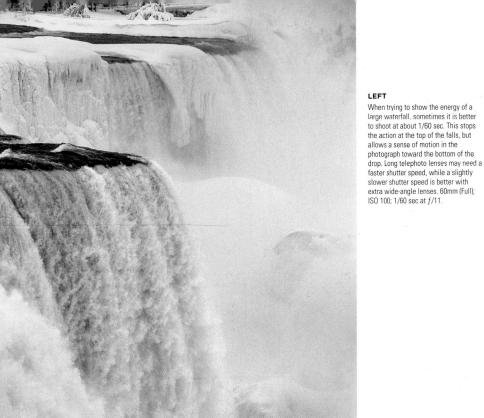

LEFT

When trying to show the energy of a large waterfall, sometimes it is better to shoot at about 1/60 sec. This stops the action at the top of the falls, but allows a sense of motion in the photograph toward the bottom of the drop. Long telephoto lenses may need a faster shutter speed, while a slightly slower shutter speed is better with extra wide-angle lenses. 60mm (Full); ISO 100; 1/60 sec at f/11.

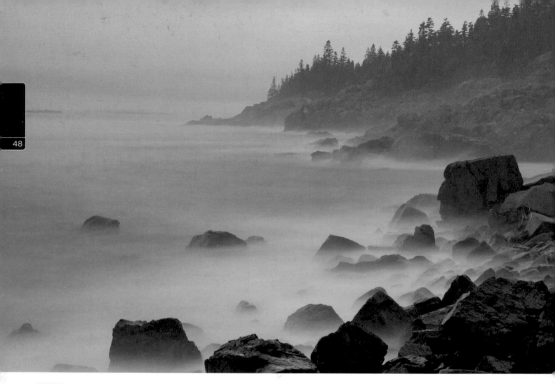

ABOVE

With moving water, extra-long exposures give a much softer effect. This 25 second
exposure was photographed in twilight. 52mm (APS); ISO 200; 25 sec at f/11.

Equipment

TECHNIQUE

49

Shooting

Creative Effects

Editing Workflow

Reference

Always think about shutter speed in relation to the focal length in order to obtain the desired amount of sharpness. Faster motion and longer focal lengths can require considerably shorter shutter speeds to stop the action in an image. A general rule of thumb is to shoot action moving perpendicularly across the field of view at 2 stops faster than if the subject was coming directly at you. If the subject is moving at a 45-degree angle, shooting one stop faster should stop the action. For example; 1/200 second is required for a sharp photo with a 200mm lens, 1/400 second should stop action moving at 45 degrees, and 1/800 should stop most action moving sideways across the field of view.

To create motion blur, work with shutter speeds at least three or four stops slower than those needed to stop the action. One of the most common uses for slower shutter speeds and motion blur in landscapes is to soften the effect of moving water. Using a shutter speed of 1/8 second or longer with the camera on a tripod is sufficient to blur water with most any focal length. The longer the shutter speed, the greater the softness in the motion. Another way to portray motion is by panning. The key is to "track" the subject, using a shutter speed that is slower than needed to stop the action. Panning is covered further on page 156.

TOP LEFT

The wind was blowing occasionally while I was photographing the monarch butterfly on asters and I slowed the shutter speed down to 1/15 sec at f/22, to see how the motion would look in a photograph.

TOP CENTER

Opening the aperture to f/8 to isolate the monarch from the foreground and background asters, gave a shutter speed of 1/250, which assured a still, sharp photo of the butterfly, even if there was slight movement while the photo was being taken.

TOP RIGHT

About 1/6 or 1/8 sec is a good shutter speed to portray water motion as well as some detail. Too long an exposure softens the intensity of the reflected highlights.

ISO Options

The ISO setting adjusts the sensitivity of the camera's sensor to light. Just as with film speed, low ISO numbers are less sensitive to light and require longer exposures, while "faster" film has higher ISO settings and can be used in lower-light situations. Like film, the most noise-free and sharpest images come from images shot at lower ISO settings, while high ISO settings create images that have softer edge detail, and varying amounts of noise in the midtones and shadows.

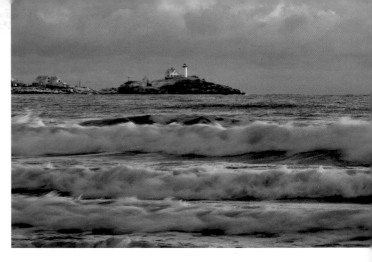

ABOVE

With the 200mm focal length, an aperture of ƒ/22 was needed so both the foreground waves and distant lighthouse were in focus. To get the 1/10 second needed to show some wave motion, I dropped the ISO to 125.

An advantage of being able to adjust the ISO for every picture frame is being able to work with specific aperture and shutter combinations in varying amounts of light. It also means that you can capture photos more easily in a wider variety of conditions than was ever possible before. While film typically ranged from ISO 50 to 1600, most DSLRs have ISO options from at least 100 to 6400 ISO. Doubling or halving the ISO number is equivalent to making a one-stop adjustment. Depending on the camera model, ISO settings may range from as low as 50 to an extended range reaching 102,400. These numbers will go even higher as sensor-processing capability continues to improve.

I tend to shoot at the default low ISO speed for the camera (typically 200), and adjust ISO settings only as needed to work with an optimal shutter speed. For a slower shutter speed, I'll use a lower ISO setting. If I need a faster shutter speed, and cannot adjust the aperture to a larger diameter, I'll use a higher ISO so the sensor is more sensitive to the available light. I do this for all shooting situations from bright sun to night photography. While higher ISO images might not have the ultimate level of sharpness, it's now possible to shoot photos that could not be captured with film.

Equipment

TECHNIQUE

Shooting

Creative Effects

Editing Workflow

Reference

RIGHT

The sun had broken over the horizon, but not yet lit the trees. Dropping the ISO to 100, with an *f*/22 aperture, gave a five-second exposure—enough to soften detail in the rapids and accentuate the swirls in the gentle whirlpool.

BELOW RIGHT

Again using a 200mm focal length, I needed a faster shutter speed to be sure to stop the action on this handheld shot, as well as a small aperture for enough depth of field to have the rock, ducklings, and most of the water in sharp focus. The only way to shoot with a shutter speed of 1/250 sec, and aperture of *f*/16 was to bump the ISO up to 800.

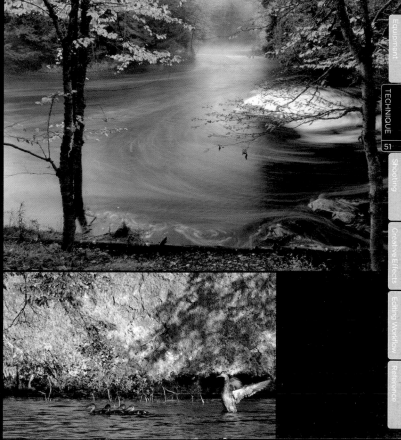

Creating the Best Exposure

Standard camera metering modes include the Spot Metering, Center-weighted Metering, and Evaluative Metering modes. Spot Metering isolates the tonal values of a specific location, while Center-weighted averages the tonal values of the whole image, weighting the central area more than the periphery. Evaluative Metering reads tonal information in different zones of the entire image and balances information from each of the segments when choosing the exposure.

All metering modes are designed to set exposure parameters as if the metered tonal values were an 18% gray. If left to the camera to choose exposure, a photograph of a completely white surface would be underexposed to a neutral gray tone, and a totally shadowed area would be overexposed to 18% gray values, rather than showing a dark shadow.

On a typical sunny day, the blue sky, green grass, and tree leaves all have about an 18% gray tonal value. Shadowed areas are darker than 18% gray, and puffy white clouds are brighter than 18% gray. Using Evaluative Metering the darker and brighter tonal values will balance each other, and the camera will still meter the image properly.

Next, let's consider a beach or snow scene. Here, the sky is blue with a few puffy clouds, there are a few trees, or a line of deep blue ocean, but the foreground is an expanse of bright, light-colored sand or snow with tonal values that are considerably brighter than 18% gray. The camera will average the tonal values of the sky, water or trees and clouds, to an 18% gray. But it will also underexpose the sand or snow and

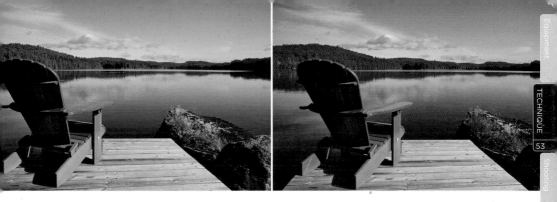

Equipment

TECHNIQUE

53

Shooting

Creative Effects

Editing Workflow

Reference

LEFT

With brighter-than-normal tonal values in an image, the camera still meters them to be average as 18% gray. This snow scene needs a stop or so overexposure compensation from the evaluative meter reading to expose the snow as white and not gray.

ABOVE

Try to visualize how close the various tonal values in a scene average out to 18% gray. Then use over- or underexposure compensation as needed to compensate for how the camera meter will expose the image.

ABOVE RIGHT

Thinking in black and white helps when visualizing the tonal values of colors. The blue sky, water reflections, and sunlit rock are about an 18% gray. The trees are darker because of the early light and shadows, but their tones balance the brightness of the clouds. The dark shadow on the chair and rock balances the brightness of the wood deck. The whole scene averages to about an 18% gray tonal value.

try to turn that an 18% gray as well. The result is a darker-than-normal image with a dark blue sky, and muddy toned snow or sand, because the camera is trying to make the bright foreground an 18% gray, and is darkening the whole image.

The easiest way to adjust exposure issues is with the Exposure Compensation feature. No matter which metering option you prefer, if an image comes out too dark, you can lighten it with overexposure compensation. If it is too light, darken it with underexposure compensation. Depending on how much white or dark area there is, a scene may need to be over- or underexposed by as much as two full stops.

I generally use Evaluative Metering for all my photos. I assess the tonal values of the various details in the image, and consider how close the average is to an 18% gray tone. I'll dial in over- or underexposure as needed, and then bracket from there by at least a full stop either way if necessary.

Exposure Value Chart

ISO related to light intensity (EV), aperture and shutter

ISO Settings							Aperture f-stops										
50	100	200	400	800	1600	3200	f/1.0	f/1.4	f/2.0	f/2.8	f/4	f/5.6	f/8	f/11	f/16	f/22	f/32
			20	19	18	17										8000	4000
		20	19	18	17	16									8000	4000	2000
	20	19	18	17	16	15								8000	4000	2000	1000
20	19	18	17	16	15	14							8000	4000	2000	1000	500
19	18	17	16	15	14	13						8000	4000	2000	1000	500	250
18	17	16	15	14	13	12					8000	4000	2000	1000	500	250	125
17	16	15	14	13	12	11				8000	4000	2000	1000	500	250	125	60
16	15	14	13	12	11	10			8000	4000	2000	1000	500	250	125	60	30
15	14	13	12	11	10	9		8000	4000	2000	1000	500	250	125	60	30	15
14	13	12	11	10	9	8	8000	4000	2000	1000	500	250	125	60	30	15	8
13	12	11	10	9	8	7	4000	2000	1000	500	250	125	60	30	15	8	4
12	11	10	9	8	7	6	2000	1000	500	250	125	60	30	15	8	4	2
11	10	9	8	7	6	5	1000	500	250	125	60	30	15	8	4	2	1"
10	9	8	7	6	5	4	500	250	125	60	30	15	8	4	2	1"	2"
9	8	7	6	5	4	3	250	125	60	30	15	8	4	2	1"	2"	4"
8	7	6	5	4	3	2	125	60	30	15	8	4	2	1"	2"	4"	8"
7	6	5	4	3	2	1	60	30	15	8	4	2	1"	2"	4"	8"	15"
6	5	4	3	2	1	0	30	15	8	4	2	1"	2"	4"	8"	15"	30"
5	4	3	2	1	0	-1	15	8	4	2	1"	2"	4"	8"	15"	30"	1'
4	3	2	1	0	-1	-2	8	4	2	1"	2"	4"	8"	15"	30"	1'	2'
3	2	1	0	-1	-2	-3	4	2	1"	2"	4"	8"	15"	30"	1'	2'	4'
2	1	0	-1	-2	-3	-4	2	1"	2"	4"	8"	15"	30"	1'	2'	4'	8'
1	0	-1	-2	-3	-4	-5	1"	2"	4"	8"	15"	30"	1'	2'	4'	8'	16'
0	-1	-2	-3	-4	-5	-6	2"	4"	8"	15"	30"	1'	2'	4'	8'	16'	32'
-1	-2	-3	-4	-5	-6		4"	8"	15"	30"	1'	2'	4'	8'	16'	32'	64'
-2	-3	-4	-5	-6			8"	15"	30"	1'	2'	4'	8'	16'	32'	64'	128'
-3	-4	-5	-6				15"	30"	1'	2'	4'	8'	16'	32'	64'	128'	
-4	-5	-6					30"	1'	2'	4'	8'	16'	32'	64'	128'		
-5	-6						1'	2'	4'	8'	16'	32'	64'	128'			
EV (Exposure Values)							Shutter Speeds (fractions of a second, seconds, minutes)										

EV CHART EXPOSURE VALUES AT 100 ISO

The following grid lists a range of common landscape situations, and their corresponding Exposure Value. By plotting these values on the EV Chart on the left, you can determine the exposure settings for any lighting condition. All of the settings are based on full *f*-stops.

EV	Typical subject		
-6	Starlit night sky	+6–7	Lights in fairs and amusement parks
-5	Crescent moonlight, faint aurora	+7–8	Bright street scenes, dawn and twilight
-4	Quarter phase moonlight, medium intensity aurora	+9–11	Just before sunrise or just after sunset
-3	Full moonlight, bright aurora	+12	Heavily overcast, or open shade with sunlight
-2	Full moon light on a snowscape	+13	Cloudy, bright with no shadows
-1–+1	Nighttime city skylines (varying intensity of light)	+14	Hazy sunlight with soft shadows, or bright sun low in sky
+2	Distant lit buildings (at night)	+15	Bright sunlight overhead with sharp shadows
+3–5	Floodlights on buildings and street lights	+16	Bright sunlight on snow or light sand
		+17–20	Specular sunlight reflections, intense manmade lighting

Another method to choose exposure is to select your exposure data with a gray card, or the palm of your hand. By holding either in the same plane of light as the film plane (sensor) in the camera, the intensity of light on the shadowed palm, or gray card will read pretty true to an 18% gray tone for the photo. Fill the frame, then adjust and lock in your exposure data, recompose, take the photo, and bracket as needed.

The "Sunny 16" rule is a guideline for setting exposure without using a meter. On a bright sunny day with good sharp shadows, using an aperture of *f*/16, with a shutter speed of 1/ISO, will provide an optimal exposure. Note this setting on the Exposure Value Chart. A bright sunny day has an EV of 15. Find 15 under ISO 100, follow it over to 1/125 second and then to *f*/16.

While it is generally easier to use the camera's auto-exposure features, there are times when it can be helpful to use the EV chart. In daylight situations where the sun or other bright light source is in the image frame, or when working under the moonlight or artificial light at night where the light is less than the camera's light meter can read, the chart can be used to determine approximate exposure settings. First estimate the EV value from the various lighting situations, then choose the corresponding ISO, aperture, and shutter setting from the chart.

Metered images of a sunrise or sunset with the sun in the image, will need a stop or more overexposure compensation to balance the brightness of the sun. Once the sun is below the horizon, underexposure compensation is needed to capture the color in the sky while the camera balances the foreground darkness with the brightness of the sky. Metering directly off the sunset tones on clouds in the sky will result in good sky colors and detail.

Silhouettes are created by underexposing darker foreground detail against a lighter background. This can be done easily in high-contrast situations by using underexposure compensation, or by exposing the image for the bright background which will render the foreground dark or black.

RIGHT

Captured in twilight during a
snowstorm. There was a nice softness
in the air, and tonal balance between
the Christmas lights and the subtle
light on the landscape. Be sure to
bracket and check the exposure data
since the camera metering could
tend to underexpose this image as the
lights are mostly in the center of
the image. 20mm (APS); ISO 200; 5 sec
at f/8.

Working with Exposure Compensation

- Work in any of the program modes (Aperture Priority, Shutter
 Priority, or Program).
- Photograph something quite light—snow, sunlit sand, a white car,
 or white birch bark.
- Review the image and check the histogram. The image
 is most likely darker than it should be, and the histogram will
 show that the bulk of the brighter tones are closer to the middle.

- Adjust the Exposure Compensation to 1 stop overexposure and
 take a shot, then to 2 stops overexposure and take another shot.
- Review each image, checking the histogram to review the data
 and see which comes closest to what your eye perceives.
 Experiment also with darker-than-average subjects and go through
 the same process using underexposure compensation.

ABOVE

Choosing exposure is a mix of understanding how the camera's metering works, and how the tonal values in the scene you are looking at correlate with 18% gray. 20mm (Full); ISO 100; 1/50 sec at $f/22$.

Exposure Tips:

- The "Sunny 16" rule: On a bright sunny day with sharp shadows, the exposure is 1/ISO second at $f/16$.
- Camera meters base exposure for metered information on an average 18% gray tonal value.
- If an image comes out too dark, use overexposure compensation, if it is too light, use underexposure compensation.
- Sunrise/sunset: With the sun in the image, use some overexposure compensation. Once the sun is down below the landscape horizon, use some underexposure compensation—or meter directly off the tones in the clouds and shoot with those settings.
- It's better to slightly overexpose a digital file—pulling detail out of a darker image creates midtone and shadow noise. However, be careful to get enough detail in highlight areas.
- Turn on the "Highlights" feature for playback to easily see any overexposure when reviewing images.
- In challenging light check exposure by metering off a gray card or the palm of your hand—held in the same plane as the photo being taken.
- Bracket, bracket, bracket! The best way to ensure you obtain the needed dynamic range in a single shot, or throughout a group of photos, is to bracket the image by shooting varying over- and underexposures of the same image at least a stop apart.
- The best image is still the one with the best exposure. You can't get details from either the highlights or the shadows if the information isn't there to work with.

White Balance

Adjusting the white balance affects the overall color tones of a photograph. Every lighting situation has its own color balance. Our eyes have their own "white balance" and perceive a more neutral color balance in many situations where a camera will record the actual color on the landscape.

The camera's white balance adjustment affects JPEG or TIFF images that are processed in the camera, but does not affect Raw files in most cameras. Since I primarily shoot Raw, I have the white balance set to "Auto" most of the time. It's easy to adjust the color balance of Raw files in an image-editing program, where there is wide scope for adjustment.

While Auto will still cover many JPEG and TIFF shooting situations, it is still helpful to perceive and understand the overall tones of light in different situations. Any shadowed object that is reflecting light will take on the hues of the light falling on it. Under a blue sky, shadows take on a bluish tone, especially when the scene is snow-covered. Around sunrise and sunset, the whole landscape is essentially in shadow, and takes

BELOW

The tonal values in misty conditions will have blue overtones if the sky above is clear. Auto-white balance is fine for Raw, but it could be best to shoot this under the "cloudy" setting if doing JPEGs.

BELOW

Incandescent lighting adds a warm glow to a scene. If it's too much, adjust the white balance to the incandescent setting.

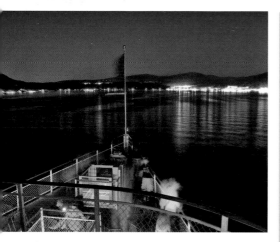

Equipment

TECHNIQUE

59

Shooting

Creative Effects

Editing Workflow

Reference

Color Temperature Light Source

1000–2000K	Candlelight
2500–3500K	Tungsten Bulb (household variety)
3000–4000K	Sunrise/Sunset (clear sky)
4000–5000K	Fluorescent Lamps
5000–5500K	Electronic Flash
5000–6500K	Daylight with Clear Sky (sun overhead)
6500–8000K	Moderately Overcast Sky
9000–10000K	Shade or Heavily Overcast Sky

– 10,000 –
– 9,000 –
– 8,000 –
– 7,000 –
– 6,000 –
– 5,000 –
– 4,000 –
– 3,000 –
– 2,000 –
– 1,000 –

Color Temperature

Adjusting the color temperature in the camera to the temperature of the different lighting will give an overall neutral tone to the image. The white balance presets on many cameras offer a quick way to adapt JPEG files to changing lighting conditions.

ABOVE

Where do you set the white balance? This image has it all except sunlight—twilight blue, incandescent light, and fluorescent light. This is a good time to shoot Raw so each tone can be tweaked as needed in an image-editing program.

on the hues of the light from the sky. An overcast sky filters out the warmer color tones from the sun's light, giving the landscape a more bluish hue.

Note the general color tones in the chart associated with the different lighting situations. The camera's white balance can be set by either using the presets, or manually adjusting the color temperature according to the chart to give an overall neutral tone to the image. Most cameras also have options for white balance bracketing so you can field check the images and make adjustments, or choose the best image later.

A gray card can also be used to set white balance. One method is to shoot one image sample with the gray card in the image for reference later when using a midtone eyedropper in a Levels or Curves layer in Photoshop. Another method is to shoot the gray card full-frame on automatic and use those settings to adjust the custom white balance setting. The final rendering, though, is all up to the effect you are working to portray.

Understanding Histograms

A histogram graphically shows the distribution of specific information. In photography, the histogram graph represents the tonal values throughout each image. Since the histogram is the single most important feature in determining whether the photo is properly exposed, it's best to check it on almost every image you shoot. While histograms are available for checking each of the primary colors (RGB), the luminosity histogram is easiest to work with.

Reading a histogram is really quite simple. The far left of the histogram is a pure black point (0), and the far right is pure white (255). The crests and valleys of the curves in between show the accumulated tonal values throughout the image.

For example, if there is a predominance of mid-range tonal values, the graph will be high in the center. If the image has a quantity of brighter tones as well as a high level of darker tones, the graph will most likely be high toward the black end, lower in the middle, and higher again toward white.

While there are times it can be helpful to understand whether the tonal values in an image are darker or brighter, the most critical points to check are the white point, and the black point. If the line of the graph stops short of either end of the histogram, then there is tonal detail in the highlights and (or) the shadows. If the line continues to—or spikes at—either the white or the black points, tonal information is clipped. This means there are sections of the image with absolutely no detail that have been rendered as pure white or black.

Images photographed in soft lighting are more likely to have all of the tonal values fall cleanly within range of the

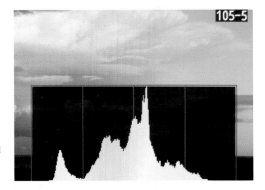

ABOVE AND RIGHT

The dynamic range of an image does not necessarily go from the white to black points. This image of the clouds and ocean has only about a 6-stop dynamic range.

histogram and may even have a quite narrow band of tonal information that doesn't come close to either white or black. However, images shot with brighter, and more contrasty light will most likely have values that exceed the tonal range that can be captured by the digital sensor. The choices then, are to decide whether you want more blacks in the shadows, or whites in the highlights; or whether to shoot a bracketed set of images that can be composited for HDR work.

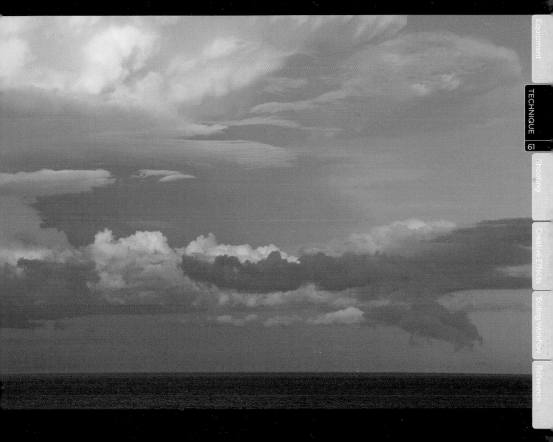

Equipment

TECHNIQUE
61

Shooting

Creative Effects

Editing Workflow

Reference

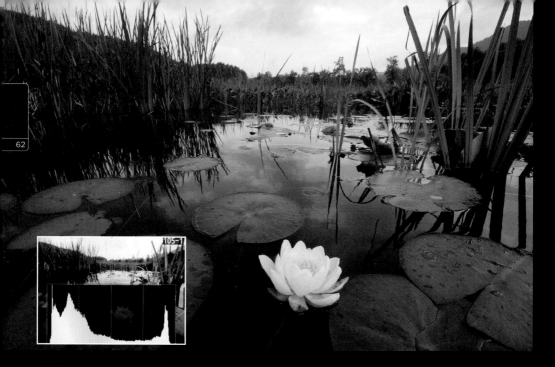

ABOVE

This image shows a good histogram. The graphed line ends just short of white on the right, and drops down completely to black at the line on the left. Note the sky and water lily petal detail in this image that is blown out in the overexposed image on the right.

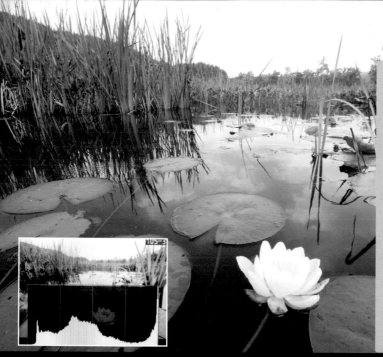

Equipment

TECHNIQUE

63

Shooting

Creative Effects

Editing Workflow

Reference

Histogram Tips

- Most important is checking the white point and the black point for clipping (where the line of the graph meets either the white or black points).
- It is not necessary to achieve a "bell curve," the graphed "curve" simply shows the various tonal information compared to black, neutral, and white throughout the image and may have different peaks and valleys related to the tonal values of the scene.
- It's fine if the dynamic range of the image does not reach from black to white. Readjust the exposure lighter or darker so the tonal range falls where you want it in relation to the black/white values.

ABOVE
In this overexposed image the graph shows a line stacked up against the white side. Any image information at that brightness level or beyond has been clipped and will be pure white, with no detail.

Bracketing and HDR

Bracketing is the process of shooting a range of overexposed and underexposed shots of the same image (preferably from a stable tripod), that capture the full range of tonal information within a series of images. This can be done manually by adjusting the Exposure Compensation for each successive shot, or automatically in-camera with autobracketing features. When using autobracketing, and the shooting mode is set to continuous, holding down the shutter release will trigger the camera to shoot a full set of bracketed images and then stop.

With film, bracketing your photos was a way to achieve an optimal single exposure (along with adding neutral density filters and other tweaking). With digital photography, bracketing is a way to record a sequence of photos that capture the full tonal range in high-contrast situations to create one perfect exposure by using HDR methods to create a composite with software. Some cameras also offer the capability to do compositing and HDR in the camera.

A key to comprehending this concept is understanding the dynamic range of what you are photographing compared to the dynamic range capability of your camera's sensor. The human eye has the capability to discern detail at the same time over roughly a 13–15 f-stop range of light. Slide film has a tonal range of about 5 stops, negative film about 7 stops, and most digital sensors capture about an 8-or-9 stop dynamic range. In a high-contrast situation, even if the camera records the exposure in the middle of the range, at least a 2-stop range of shadow information will be recorded as black, and a

ABOVE

I set up my camera to bracket five images that covered a range of two full stops either side of neutral. By combining the 2-stop underexposure for sky detail, with the 1-stop overexposure for the foreground detail, I was able to create a final image that reflected the overall detail my eye was picking up.

2-or-more stop range of highlight information recorded as white. Dark or light tones in a scene that shows plenty of detail to the human eye will become quite dark or light in the photo.

Histogram use is key in determining how extensive a range of exposures is needed to capture all of the highlight and shadow detail within a set of images. My D300S can do both a 5-stop over- and underexposure. It also autobrackets up to nine exposures a full stop apart. While at least 70 percent of my bracketing are three-image sets—one neutral, one stop over, and one under—there are times I will do as many as seven in a set, and on rare occasions the full nine brackets. My goal is to have all the tonal information I need for an HDR composite. The more unique the lighting and situation, the more stops I will bracket, just to be sure I fully capture all the tonal information in special conditions I may never see again. It's easy to delete a couple of extra frames later—but they can never be recreated if they didn't exist.

Note the difference in these two images. The top one was shot with a split ND, and the lower one was created using HDR.

Bracketing steps for HDR

- Assess the scene for effective exposure visually, and use Exposure Compensation if needed.
- Take a photo then check it: Are overexposed highlights flashing? Is there any black or white point clipping in the histogram?
- Bracket by at least a full stop for digital, by half stops or third stops for film.
- Autobracket: Set camera to continuous shooting mode, adjust the over/under range for the autobracket sequence, press and hold the shutter release to shoot a full bracketed sequence (best done on a sturdy tripod with a cable release).
- Or manual bracket: The easiest is to use Exposure Compensation—for digital cameras bracket by at least a full stop. Take additional shots and adjust the compensation by as much over or under as is needed to capture both black and white point tonal detail.
- Or manual bracket #2: Set the exposure data in Manual mode, then bracket with either the aperture or shutter adjustments.
- Next, check the histogram on every bracketed shot to be sure you have both white point and black point detail.
- Check sharpness to be sure of image quality.
- If you have full tonal detail and sharpness, then you can set up for your next shot!

In the right situations, split neutral density filters can be used to darken a bright sky or other areas in an image to reduce the amount of bracketing needed. However, any part of the landscape within the filtered area will be darkened also. Using bracketing and HDR techniques instead of filters reduces this darkening issue.

Equipment

TECHNIQUE

65

Shooting

Creative Effects

Editing Workflow

Reference

LEFT, BELOW LEFT, BELOW RIGHT

The average exposure and histogram. Note on the black side (left) the graph almost touches the black point, and it shows a fair amount of the image is dark. It also shows the spike at the white point with the clipping of detail from overexposure in the highlights.

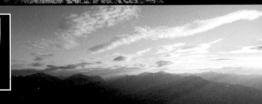

LEFT, ABOVE LEFT, ABOVE RIGHT

2 stops underexposed. Note how the dark detail piles up against the black point, and the clipping of detail that is occurring there—and how the graph just barely touches the white point on the right.

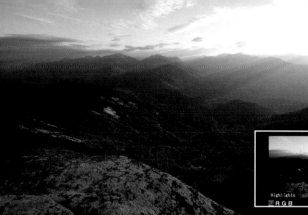

RIGHT, BELOW LEFT, BELOW RIGHT

This 1-stop underexposure shows clipping at both the white and black points.

RIGHT, ABOVE LEFT, ABOVE RIGHT

This 1-stop overexposure eliminates the clipping at the black point, and brings much more detail into the darker areas of the image, while totally blowing out all detail in the highlights.

Manual Focus vs. Autofocus

I generally use autofocus for action and quick-focus situations, and manual focus for depth of field situations where the hyperfocus point is more critical. Autofocus works well on reasonably defined subjects with few other conflicting lines of detail.

Autofocus settings have two basic options with additional parameters that can be changed in the custom settings menu. In Single mode, the camera focuses on a specific subject, and will only take the shot once it is in sharp focus. In Continuous mode, autofocus keeps adjusting to moving subjects, making it easier to take sharp images of wildlife, athletes, or any subject that is in motion. Some cameras offer the option of 3D tracking that can help predict the position of subjects that are moving somewhat erratically.

LiveView has different focusing options that depend on whether it is in handheld or tripod mode. In tripod mode, move the point of focus on the LiveView screen, zoom into the image to focus on a specific point and then scroll around to check the detail focus throughout the image. LiveView though, may not show the effect of changing the aperture size. (On a Canon this can be done by pressing the depth of field preview button.)

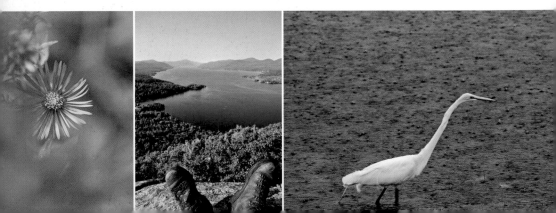

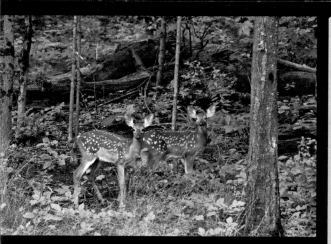

Equipment

TECHNIQUE

69

Shooting

Creative Effects

Editing Workflow

Reference

Focusing Tips

- Autofocus is triggered by either pressing the shutter release button halfway, or pressing the AF button.
- The number of on-screen focus, or exposure selection points, is adjustable on most cameras.
- For general shooting I use the maximum number of points.
- With only a central focus point: If a subject is off-center, reposition so the subject is centered, focus, and lock the focus point by holding the shutter release halfway. Then recompose and shoot.
- Or, focus on the subject, press and hold the AF button, recompose, and shoot.
- With multi-focus points, adjust the selection point to the subject if possible and then shoot.
- The AE/AF L button can be can be set up a number of different ways to lock focus, exposure, or both at once.
- Remember to unlock the AF and exposure before shooting a different scene.
- In LiveView > tripod mode, choose the subject area by moving the focus point. Focus with the AF button, or zoom into the image and focus manually on specific detail.
- For motion with Manual focus, or when autofocus won't work well, prefocus at a select distance for the anticipated subject location.
- Once comfortable with autofocus use, customize the settings to your preferences.

ABOVE

Dynamic multiple-point autofocus is the easiest way to capture spur of the moment images of wildlife or people. 200mm (APS); ISO 500; 1/40 sec at $f/8$.

FAR LEFT

Some situations are as much about what not to focus on as they are about the actual focus. This is a careful mix of working with focus and the aperture setting for depth of field. 105mm (Full); ISO 100; 1/100 sec at $f/4$.

CENTER LEFT

I needed a fast enough shutter speed for hand-holding, a small enough aperture for depth of field, and be able to set the hyperfocal point so the butterfly, boots, and the background would be in focus. The only way to do that accurately was with manual focus. 16mm (APS); ISO 200; 1/50 sec at $f/16$.

LEFT

While fog, mist and a lot of lines in a scene can cause issues with autofocus, having a sharp line of contrast makes it easier to focus on the subject. 135mm (APS); ISO 400; 1/20 sec at $f/8$.

Shooting for Post Production

For some years I have photographed for the end result, shooting each photo so I have all the image data needed to recreate the full mood and tonal qualities of the landscape in one final image file. This is a different concept from shooting with the premise that everything can be "fixed" with software. Remember that the best photos still start with effective composition and lighting. Post-processing allows you to shortcut some shooting processes, reducing the need for filter use and other extras during shooting. It also lets you create images from multiple exposures that offer a more natural feel.

For a better understanding of how to maximize each image's potential, it's important to understand image-editing possibilities,

as well as digital image file limitations. Many options that are available when shooting can also be added during post-processing. Color enhancement, tonal adjustments, white balance, filter use, compositing and other special effects can all be applied in post production if you have captured all the necessary information in the original image. This applies to both image enhancement and image manipulation. Enhancements may include working with digital filters, tonal adjustment, and HDR to adjust tones and colors. Physically changing the image in some way, by adding a different sky, taking out telephone poles or branches, or adding an animal, is image manipulation.

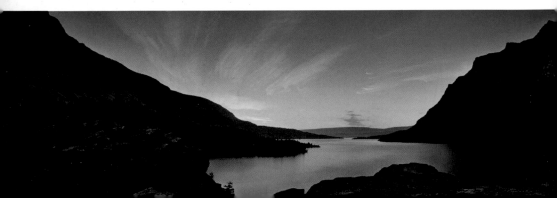

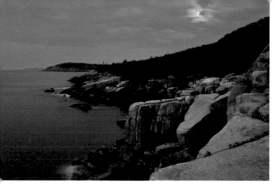

Equipment

TECHNIQUE

71

Shooting

Creative Effects

Editing Workflow

Reference

LEFT

During the 30 sec exposure for the rocky shoreline, the moon moved and was also considerably overexposed. The only way to bring twilight moon detail and landscape detail together in the same shot is to create a composite of two shots, one exposed for the landscape and another for the moon. 20mm (APS); ISO 250; 30 sec at *f*/22.

OPPOSITE

A split neutral density filter over the sky area would darken the adjacent landscape way too much. In this situation, the best way to get sky detail, as well as foreground and mountain detail, is with bracketing and HDR work. Seitz Roundshot panorama camera; ISO 100; 1/2 sec at *f*/8.

Thinking Ahead for Post Production

- Shoot for the overall effect of rendering a final photo from composited image details.
- Raw files are best for post-processing since they contain the greatest amount of image information. Shoot Raw/JPEG at once if JPEGs are desired for general use.
- Photograph the entire dynamic range with full shadow and highlight detail in a single image or in a bracketed series.
- Color balance and enhancement are easy post-processing adjustments.
- Soft-lit scenes are often easier to adjust in post-processing than contrasty ones.
- Split ND filters are helpful as long as they don't darken any of the landscape or create a tonal shift line across the image.
- ND filters are still helpful to darken a scene for additional motion blur.
- Depth of field can be adjusted with the lens aperture, or by digitally compositing a sequence of images that capture the full range of focus desired.
- Experiment! Just because you haven't done it or read about it before doesn't mean it's impossible. The worst that can happen is that you delete some extra frames—the best could result in a really special, unique image.

BELOW

Think about the tonal range in this photo. There is detail in the sky around the sun, as well as in the shadowed hull of this black carbon-fiber Hornbeck canoe. While it's best to use a tripod for shooting bracketed photos, it is also possible to align handheld images in post-processing to do HDR work. 10mm (APS); ISO 200; 1/125 sec at *f*/18.

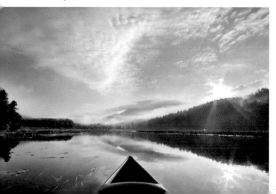

Video Tips

Although I feel a still image has a more memorable impact than a moving picture, video captures motion, mood and sounds that stills cannot, and offers some fun, creative options in the field. I enjoy the video capability of my DSLR to help communicate a "feeling of place," recording the actual motion of waves crashing on a rocky shoreline, or tall grasses undulating with the wind.

While the only difference between 720 and 1080 video is overall pixel dimensions, there is a quality difference between progressive (P), and interlaced (I) video. Interlaced video is traditional cathode ray tube scanning technology whereby the image is separated into odd and even lines that are alternately refreshed at about 30 frames per second on screen. Progressive signals, however, send the entire frame at once, scanning lines sequentially, offering a cleaner image with sharper detail and fewer flickering issues.

Video recordings and digital stills have similar dynamic range issues. White and/or black detail will be clipped if the dynamic range of the landscape exceeds that of the sensor. To get the best color and detail, check histograms, work with Exposure Compensation, white balance, and add split ND filters if needed. HDR video techniques are currently being developed, which may add a more natural look while capturing the full dynamic range in future video recordings.

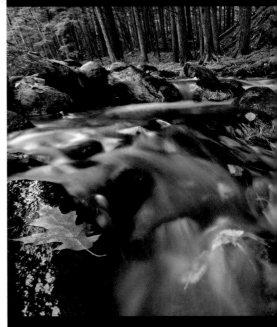

ABOVE
Once I have set up the composition for a still, it is easy to shoot a video clip as well. 10mm (APS); ISO 100; 4 sec at f/22.

Equipment

TECHNIQUE

73

Shooting

Creative Effects

Editing Workflow

Reference

LEFT

While a still image offers a unique perspective of motion, the only way to really see and hear the waves pounding on the rocks is to shoot a video clip in addition to the still. 22mm (APS); ISO 100; 1 sec at f/10.

Video Tips

- Use AE L Auto Exposure lock to help keep video from "flickering" as the aperture adjusts to changing light intensity. Check the custom function to have it "hold" the exposure when pressed once. Remember to turn it off when done!
- Stabilized lenses help with handheld video, but can add camera noise to the soundtrack. Turn off lens stabilization when the camera is on a tripod.
- An external stereo mike helps avoid focusing, stabilization, and other camera noises, and is often better for wind noise issues.
- To change the depth of field, adjust the aperture while in either Aperture Priority or Manual mode before starting LiveView and video recording. Use manual focus to set a hyperfocal point. Some cameras have aperture size limitations.
- The camera automatically chooses shutter speed and ISO while recording.
- Avoid pointing the camera at the sun or other intense light sources during recording.
- Rather than zooming while shooting, blend separate clips recorded at different focal lengths.
- Video heads on a tripod help smooth panning motion.
- Composition guidelines are similar to that for stills. Allow space for subject energy to travel into. Video is about action, energy, and motion.
- Time-lapse video can be created from a sequence of still images shot using an interval timer.

SHOOTING

The range of photographic possibilities is endless. "Visualize, compose, and shoot," is a mantra that encompasses the whole photo-taking process. Digital cameras and editing technology may make it much easier to capture and create great photos, but you still have to be there at the location and "see" the photo in order to shoot it in the first place.

"Experiment" is another facet of the mantra. Try new techniques and equipment, and check out different angles to help you envision subjects in new ways while becoming more comfortable with camera principles and mechanics. Although it's possible to take great photos without fully understanding the mechanics of the camera or the rules of composition, being able to consistently bring back top quality images is dependent on a thorough understanding of both.

Equipment

Technique

SHOOTING

75

Creative Effects

Editing Workflow

Reference

Once a subject catches your attention, close one eye and visualize it as a two-dimensional photo. Next, refine the composition, defining exactly what you want to portray within the frame. Finally, shoot the photo. This can be as simple as pressing the shutter release, or may involve further steps based on your judgment of what the shot needs considering weather conditions, lighting, and perspective, as well as aperture, shutter, lenses, filters, hyperfocus point, and any special effects you might want to incorporate. The better you understand each step, the easier it is to experiment and create fresh, unique photos every time you shoot.

LEFT

Understanding where light will fall in relation to the landscape helps put you in the right place at the right time. Lake Durant, Adirondack Park, NY. 18mm (APS); ISO 200; 1/8 sec at f/11.

Perfect Pictures Every Time

Creating a "perfect picture every time" is a combination of understanding camera mechanics as well as composition. Being able to review each image in-camera is the best tool for learning composition since it allows you to hone the photo to the optimal composition while still being on location. Using digital, I shoot a greater variety of angles and compositions of a single subject or scene than I ever did with film. Experimenting with various angles, using different focal lengths, perspectives, exposures, and depth of field, often creates more unique imagery than shooting just one or two images.

While not every photo ends up being a "perfect picture," working through a few particular steps will help confirm that the pictures you do take have the potential to be perfect. This is a four-step process I work through with every photo or bracketed set of photos I take, unless I am very sure of my settings.

o Check the composition for overall tonal balance, as well as any stray details and distractions around the edge of the photo, or "growing" out of a subject. Things can commonly creep into the edges of images taken on a camera with a less than 100 percent viewfinder.

o Check the tonal information—first with the Highlights alert, and then with as large a histogram as possible.

o Check the image sharpness, zooming fully into the image to where pixels appear, then back out one zoom level. Compare edge detail sharpness from the closest subjects in the photo, to the mid range subjects, to those furthest away. Edges might not appear tack sharp on the screen, but each should have similar sharpness relative to others throughout the depth-of-field range.

o Check a full set of bracketed images for detail sharpness, and with the histogram, to be sure the set encompasses a full range of tonal information and that each image has the necessary sharpness from foreground to background.

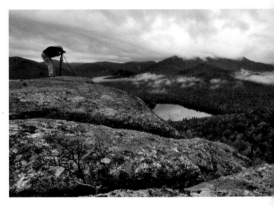

ABOVE

Perfect pictures are a combination of light, mood, lines, texture, tonal balance, and getting all the tonal information needed for the image. On Mt. Jo, Adirondack Park, NY. 11mm (APS); ISO 200; 1/20 sec at f/22.

Equipment

Technique

Creative Effects

Editing Workflow

Reference

BELOW
Check every corner of the viewfinder during image composition, then zoom into the image during payback and check foreground, middleground, and background subjects for detail sharpness. Heart Lake, Adirondack Park, NY. 10mm (APS); ISO 200; 1/80 sec at f/22.

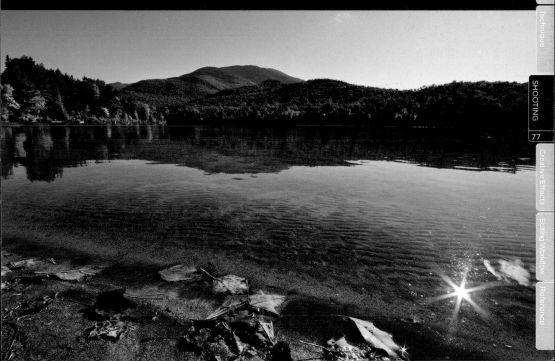

Visualization

It's not what we see, it's how we see it. Most of my images evolve from something that "catches my eye." It could be a single detail, or a pattern, texture, or grand landscape. With details or patterns I'll consider whether they are part of a larger landscape view, or whether the detail is the photo itself. If a landscape view is "eye catching," I'll look for what makes the view unique and special, and work with any details and textures that enhance the view, and draw me into the picture.

Visualize the photo around what is there, but also about what is not. Consider how views might look from other vantage points, or with different weather and lighting, or how a long exposure might affect subject motion. Various focal lengths, filters, creative options, and post-processing might enhance the photo in other ways and help you create a really special image. The more you experiment with different lenses and techniques, the easier it is to "think like a camera" and create fresh images wherever you are.

Work with your imagination when visualizing a photo. While recreating a well-known picture can be part of the learning process, photograph what has the most meaning for you at that particular moment. The images will then become "yours," and be completely unique.

LEFT
Trying different perspectives and lenses is both fun and useful, opening your eyes to different possible viewpoints to shoot from. 10.5mm fisheye (APS); ISO 250; 4 sec at $f/22$.

BELOW
It's easy to see the river, but more of a challenge to find the reflections and details within. 200mm (APS); ISO 400; 1/15 sec at $f/16$.

Equipment

Technique

Creative Effects

Editing Workflow

Reference

RIGHT AND BELOW
Look for details within the larger landscape that could become an interesting photo on their own.

Visualization Tips

- Seek out and key in on the details that catch your eye.
- Close one eye to eliminate our 3D perceptions when visualizing a scene.
- "Think like a camera" and visualize the scene with different focal lengths, exposures, shutter speeds, and equipment options.
- Stretch your imagination beyond the obvious to different angles, perspectives, creative effects, and post-processing.
- To help put yourself in the right place at the right time, think about how other weather and lighting conditions could affect the view if you came back another time.

Composition Guidelines

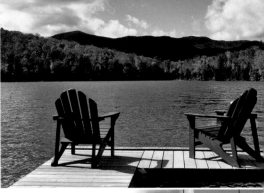

Composition is the art of defining exactly what it is you want to portray. It's about deciding which elements are most important, as well as those that aren't, to create a delicate framework of colors, tones, and textures that help convey your message. A well-composed image "feels" right, can convey all kinds of moods and emotions, and answers questions—or asks them. Good composition has a balance and symmetry that satisfies the senses, with no subject dominating and pulling attention away from this delicate balance.

The "rule of thirds" is the most common guideline used to help visualize composition. Imagining lines of thirds placed vertically and horizontally across an image helps create proportions for placement of horizon lines and subjects so an image doesn't have a center-based composition. By working with the "rule of thirds," prominent lines and subjects are placed relative to the lines of the thirds and their intersections. However, every rule for composition is really only a guideline. The only real rule in art is that there are no rules! As I look through my image collection, I find many more exceptions to the "rule of thirds" placement, compared to those that conform.

For most of the years I've been photographing, I have created imagery using a technique I'm calling "Contrast Evaluation." I work to create a balance of tones and energy throughout the image, and adjust compositional balance by working with the camera angle and focal length to simplify the photograph to the most important elements—thoroughly checking every detail within the viewfinder before clicking the shutter.

ABOVE AND RIGHT

This is a good example of both lines of thirds, as well as subject placement. The chairs are both near "thirds" intersections. What is interesting is although there is a sharp line diving water and land across the middle, the contrasting line between the shadowed mountain and sunlit trees fits the upper "thirds" line.

I look at each object in a photograph as having its own "energy," and try to balance the energy between the subjects, so the energy of one subject leads to another, and another, until it comes back to the energy of the first subject that caught my eye. This energy comes from tonal, color, and texture contrasts within each subject in the photo. The greater the contrasts in a particular subject, the greater the need for a contrasting energy in another section of the photo to maintain a balance within the image.

LEFT
While this is a center-based composition, with no thought to "thirds" during composition, the strength of the subjects around the periphery sets up a dynamic that keeps the eye moving throughout the photo.

LEFT
The best compositions rely on an overall balance between contrasting tonal intensities in different areas of the image. Simply, colors, textures, and patterns create an energetic composition that draws your eye around the photo.

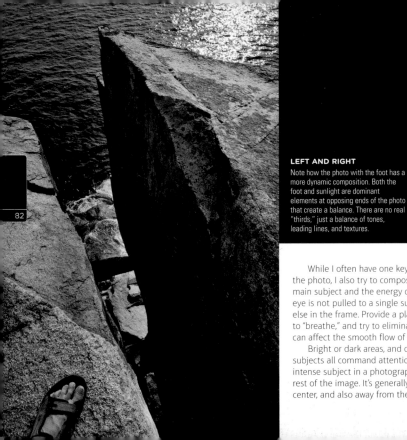

LEFT AND RIGHT
Note how the photo with the foot has a more dynamic composition. Both the foot and sunlight are dominant elements at opposing ends of the photo that create a balance. There are no real "thirds," just a balance of tones, leading lines, and textures.

While I often have one key subject that draws attention to the photo, I also try to compose with a balance between the main subject and the energy of the rest of the image so the eye is not pulled to a single subject point from everywhere else in the frame. Provide a place for the subject of the image to "breathe," and try to eliminate any distracting details that can affect the smooth flow of energy around it.

Bright or dark areas, and contrast or brightly colored subjects all command attention in an image. With only one intense subject in a photograph it can be hard to take in the rest of the image. It's generally best to place a subject off-center, and also away from the outside edge of a photo.

ABOVE AND BELOW

Placing main subjects or contrasting details at or near the intersecting lines of the thirds helps create a nice balance in a photograph. Here, the light-colored dog catches the eye and balances with the darker tones of the person and guideboat.

Composition Tips

- First, decide what the image is really about and what you are trying to communicate by asking the basic questions—who, what, when, where, why, and how?
- Why am I taking this photo, and who is it for?
- What makes this scene unique?
- When and how should I take it?
- Where is this location, and why does it have meaning?
- Composition is also about what *not* to include in a photo—be sure to check every detail through the whole viewfinder screen or LCD.
- Imagine the landscape through the perspective of various lenses and special effects.
- Consider the overall tonal balance and mood of every object in the image.
- Simplify to the essentials! Include only those details that enhance the photo, and adjust the focal length and camera perspective to eliminate any that don't.
- Move closer to, or further away from, the main subject while adjusting focal length to change the background field of view.
- It's generally better to place the main subject off center, and away from the edges of the image.
- Use a prominent foreground subject to catch the eye, then draw the eye through the rest of the photo with more subtle subjects.
- Work with lines, textures, and colors to help draw the energy from one place to another.
- Look for contrasts in size, shape, and colors to create a balance between the main subject and other details in the image.
- Dark and light areas draw the eye in a photo. Balance dark areas in one section with opposing contrasts in another area.
- Use the LCD screen to critique your photo. Zoom in slightly and scroll around to see if there is a tighter composition. Recompose and shoot again for additional editing choices.
- Remember to try both vertical and horizontal compositions.
- Experiment! It's all about playing with the camera. There's nothing to lose but some deleted photos.

Equipment

Technique

SHOOTING

83

Creative Effects

Editing Workflow

Reference

Key Composition Phrases

- Balance
- Foreground subject
- Background details
- Contrasting tones and elements
- Color and tone
- Leading lines and patterns
- Symmetry
- Viewpoint/perspective
- Framing/focal length
- Simplicity/crop to the essentials
- Eliminate distractions
- Mood and emotion
- Create depth

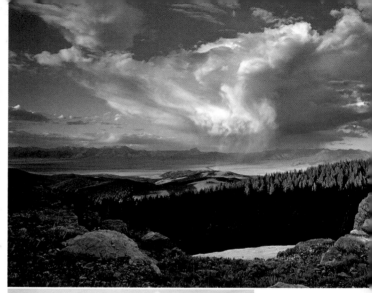

ABOVE RIGHT

This is a good example of "Contrast Evaluation." Placement of the horizon is not as important as creating a balance in the tonal contrasts and colors. The bright cloud is offset by the dark cloud to the right and the whole brighter sky area balances with the darker forest. The darker rock on the left is balanced by the sunlit rock on the right—and midtone detail, color, and lines draw your eye around the image.

LEFT

The rule of thirds offers guidelines for placement of the horizon and subject matter in a way that can offer a pleasing balance. Also—note how the subtle but distracting telephone pole in the trees on the left pulls your eye when looking almost anywhere else in the photo.

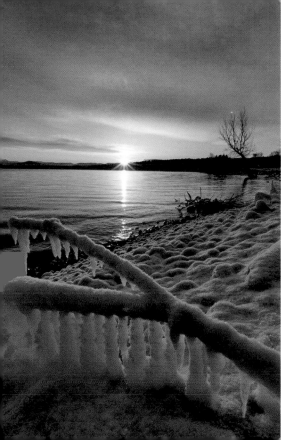

Equipment

Technique

SHOOTING

85

Creative Effects

Editing Workflow

Reference

LEFT AND ABOVE

While the horizon line and frozen branch fit the "thirds" guideline, the sun and light reflection is right in the middle. Yet, the composition works. The eye is drawn out to the patterns, color and light in the sky and water, and the brightness is balanced by the darkness of the branch in the lower part of the image. Leading lines draw the eye from the lower right to the left along the branch, then the shoreline to the tree, sun, and far shoreline in a rough "Z" pattern.

Lines, Textures, and Patterns

There are lines, patterns and textures everywhere we look in the landscape. They can be sharp and angular, soft and sensual, erratic or symmetrical, subtle or bold. While lines and textures sometimes appear as a repetitive pattern in nature, most often they are random and chaotic. A lot of the challenge in creating a great photo is in finding symmetry and balance among the chaos.

Shadow lines and edges of details, and tonal or color contrasts within or around subjects in the frame can be quite obvious and eye catching. Objects in motion have hidden lines that aren't easily seen, but appear during a longer exposure. The length of the exposure coupled with the speed and type of motion determines how defined the lines of motion are, or whether they simply disappear into a softly textured blur.

ABOVE

A golden rectangle (golden section) has esthetically pleasing proportions that have often been used for architectural design. If you remove a square from a golden rectangle, it leaves a smaller golden rectangle. An arc drawn through each of the squares creates a golden spiral.

ABOVE

A golden triangle is an isosceles triangle with side dimensions based on the proportions of the golden ratio. An arc drawn across each of the larger of the bisected bases creates a more tightly wound logarithmic spiral called an equiangular spiral, similar to that of a nautilus shell.

LEFT

The repetitive lines in the sand create a pattern that blends with the lines and texture of the water, drawing the eye to the mountains and sky.

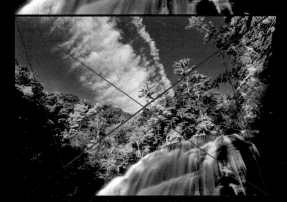

Equipment

Technique

Creative Effects

Editing Workflow

Reference

ABOVE AND RIGHT

While this image was
composed using contrast
evaluation techniques, it's
interesting to see how the lines
of golden triangles come into
play throughout the image.

LEFT AND ABOVE LEFT

The golden spiral can
be used to help explain the
pleasing symmetry of the roots
and trail in this photo.

It's important to close one eye when visualizing a composition that has a lot of intersecting lines, especially when they are at varying distances from the camera. For example, consider looking into a grove of trees. Our eyes unconsciously separate the lines of the foreground trees and branches from those further away, but a camera lens blends them together into an abstract jumble.

Golden sections, spirals, and triangles have proportions that have been used in art and architecture for thousands of years. When I'm photographing I don't consciously think about these classic lines, but am always looking for pleasing textures and patterns that enhance the flow of energy within the image and draw us from one subject to another, helping create a more dynamic photograph.

ABOVE LEFT

The flowing, sensual lines in these frosty grasses were isolated from the abundant chaotic lines surrounding them.

ABOVE TOP RIGHT

Repetitive and erratic lines and textures create interesting patterns that draw the viewer all around the photograph. The longer exposure softened the water and helped isolate the intertwined cedar branches.

ABOVE BOTTOM RIGHT

Using a telephoto lens compresses foreground and background detail so an image becomes more about lines, patterns, and textures.

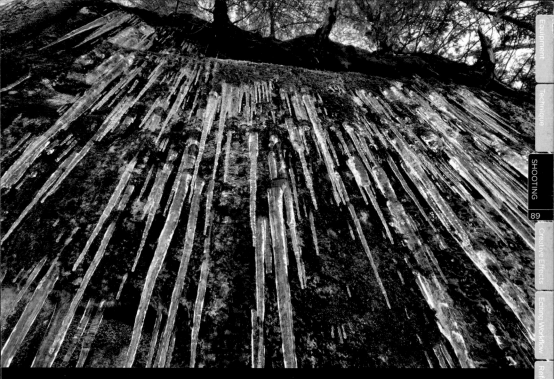

Equipment

Technique

SHOOTING

89

Creative Effects

Editing Workflow

Reference

ABOVE
Working with an ultra wide-angle lens can accentuate lines
and angles, offering a dynamic feeling of dimension.

3D from 2D

ABOVE

With a wide-angle lens, the contrast in size between the grasses and rocks in the foreground, and the shadows and colors in the landscape, draw the eye from the prominent details in the foreground to the landscape, lake, mountains, and sky. 24mm (Full); ISO 100; 1/2 sec at f/22.

Afun compositional challenge is creating a photograph that has a three-dimensional feel. Our visual perception of 3D is one of the biggest differences between what we see with our binocular vision, and what the camera sees. Since a camera sees with only one "eye," and records images on a two-dimensional surface, there is no perception of dimension unless we create it through lighting and composition.

Closing one eye while studying a scene removes our 3D component and helps us visualize the scene as the camera will. Perspective lines, shadow lines, diminishing object sizes, clouds, lighting, and atmospheric qualities that soften the image from the foreground to background all help to offer a sense of depth, and give the impression of three dimensions in a two-dimensional photograph. The low angle of the sun after sunrise and before sunset can also enhance the feeling of depth by adding soft shadows across the landscape that draw the eye across contrasting zones of shadow and light from near to far.

A wide-angle lens accentuates perspective lines and size differences, while a telephoto lens tends to compress perspective and flatten details. With short wide-angle focal lengths, it's easier to compose with subjects close to the camera, offering a greater size and perspective difference from near to far. APS and smaller format sensors need proportionately shorter focal lengths to provide a comparable field of view when compared with a specific focal length on a full-frame sensor. Because shorter focal length lenses have greater depth of field, the closest subject can be even closer to an APS camera and offer a greater sense of perspective and depth.

I enjoy composing images that give the impression a viewer could walk into them. After finding eye-catching subjects for the foreground, I'll compose the image to give the viewer the feeling of being at the closest subject, looking into the rest of the view from the perspective of the foreground. I work with hyperfocal settings to maximize depth of field, adding compositional elements with scale and perspective, to draw the eye from foreground to background, creating a three-dimensional effect.

ABOVE

A hyperfocused wide-angle lens accentuates the size of closer details. The size difference in similar objects, plus the leading lines of the animal tracks, draw the eye from foreground to background and create a sense of depth, dimension, and space. 20mm (Full); ISO 100; 1/4 sec at ƒ/22.

ABOVE

In addition to the size contrasts between the flowers, chairs, geese, and horizon, the tonal contrasts of the bright foreground flowers and background sun and sky help draw the eye from the foreground to background. 13mm (APS); ISO 200; 1/25 sec at ƒ/16.

LEFT

Even though this was shot with a normal lens, the relative size of the birches lining the footpath plus the perspective lines and size difference of the green grass along the footpath, draw the eye from the near trees to the distant center, offering a sense of dimension. 35mm (APS); ISO 250; 1/2 sec at ƒ/16.

BOTTOM LEFT

With the porch posts framing the foreground and the leading lines of the walkway drawing you to the lighthouse, this image has a feeling of 3D even in the low, soft light. 18mm (APS); ISO 320; 1/200 at ƒ/16.

Equipment

Technique

SHOOTING

Creative Effects

Editing Workflow

Reference

Panoramas and Image Blends

Panoramas offer a unique way to portray the landscape. I well remember the first time I stood on top of a mountain with my new panoramic camera, and how special it was to be able to capture the full view on one piece of film. Today, there are digital panoramic cameras available, but with stitching software anyone can easily shoot panoramic images with a regular digital camera.

Digital image files can be blended horizontally and vertically to create panoramas, or higher resolution images of standard format scenes. When composing and shooting, remember wide-angle lenses have angular distortion that will be corrected with software during compositing. While it is possible to work with a selection of images that have the same orientation as the final, it is best to shoot the selection at 90 degrees to the final orientation for the greatest options when stitching and cropping the final image in a stitching program.

The rules of composition are the same as for standard format images with one exception. All the general guidelines for composition apply—contrast evaluation for tonal balance, thirds, perspective lines, lighting, and depth of field. The issue is that standard format lenses are rectilinear and corrected for straight-line distortion issues. Panoramas though, shot from one location with either panoramic equipment or stitched images, will straighten concave lines, make straight lines convex, and exaggerate the curve of lines that are already convex. When shooting panoramas, I try to set up on the inside of a concave curve so the base foreground line stays relatively equidistant from the camera and doesn't become a big "smile" in the photo.

RIGHT

Vertical panoramas can be just as dramatic as horizontal ones and can encompass what's at your feet, as well as overhead.

BELOW

I really liked the sky and wasn't able to get the full feel of sky and landscape in one image, so I shot this three-image vertical stitch with an ultra-wide lens and the camera in landscape mode for a wide view as well as extra height above and below the horizon. The high-res composite is about 4300 × 5200 pixels.

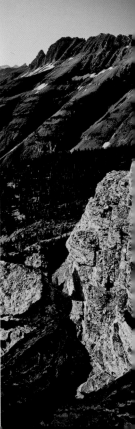

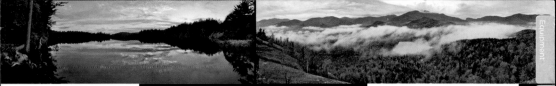

ABOVE AND LEFT

This image was photographed on a tripod with the camera in landscape (horizontal) format. The final is an HDR composite from the set of bracketed exposures. Since the stitching process adjusted the images heavily for the wide-angle lens distortion, I had to do some cloning work around the edges to fill in gaps for the final cropped proportions of about 2300 × 7300 pixels.

ABOVE AND RIGHT

This horizontal panorama was shot with the camera in portrait (vertical format). I actually handheld the camera for this sequence of images, keeping an eye on the viewfinder grid line to stay aligned with the horizon and estimating the overlap. I pulled the ends back out at the top slightly before cropping the final image from the stitched image in Photoshop. The high-res crop is about 3700 × 13,500 pixels.

Equipment

Technique

SHOOTING

93

Creative Effects

Editing Workflow

Reference

Creating Panoramas

- Assess the view for composition, visualizing the entire area for a potential panorama.
- Remember that concave lines will be straightened, and that straight lines will become convex.
- Since the photograph captures a view along an arc, relative subject size is related to its distance from the camera.
- Set up the camera with a cable release on a tripod—portrait orientation when shooting a horizontal panorama, and landscape orientation for shooting a vertical panorama.
- Select a midpoint for exposure and lock that in with manual settings, or the AE lock button (set to hold so that it keeps the base exposure throughout the panoramic sequence).
- Start from one end, framing to overshoot the view on all four sides.

- Readjust the camera to overlap the previous image by at least 30 percent.
- Bracket each panoramic frame by at least a full stop either way depending on the total range of light encompassed in the panorama. Be sure to check for highlight detail in the brightest part of the panorama, as well as shadow detail in the darkest.
- If shooting to create an extra high-res image file, shoot additional rows or columns, making sure there is enough overlap on each additional row or column.
- Stitching software is quite good today, so there is little need to worry about rotating the camera and lens around the nodal point of the lens.
- When working with normal or longer lenses, there are fewer distortion issues for stitching.

A Closer View

There are many different ways to get "close" to a subject. While a macro lens is the most common option for "close-ups," any focal length can be used to view landscape details up close. Macro and telephoto lenses magnify and isolate subjects because of the minimal depth of field, while shooting up close with wide-angle lenses captures a wide field of view with greater depth of field.

While macro lenses have dedicated features for shooting magnified close-ups, adding extension tubes between the camera and lens turns almost any zoom or prime lens into a macro lens. An extension tube kit typically consists of 12mm, 20mm, and 35mm extension tubes with built-in contacts that couple the lens to the camera. The longer the focal length, the longer the extension tube, plus they can also be combined for long focal lengths. If a focal length is too short for the length of extension tube, everything will be out of focus.

Close-up diopters screw onto the filter threads of a lens to add magnification. If stacking more than one at once, position the most powerful diopter closest to the lens.

Adding a teleconverter to telephoto lenses increases magnification without affecting the near focusing distance. However, a converter does cut the amount of light, which affects the f-stop range.

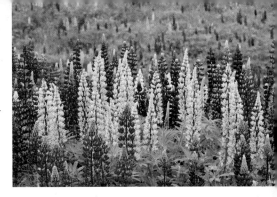

ABOVE
Using a medium telephoto lens with a smaller aperture gave good depth of field for the foreground lupines, while giving a feel for the flowers in the distant field. 90mm (APS); ISO 320; 1/40 sec at f/14.

RIGHT
Maximizing the hyperfocal settings with a 24mm wide-angle lens let me photograph the lady slipper within the perspective of its environment. 24mm (Full); ISO 100; 1/50 sec at f/22.

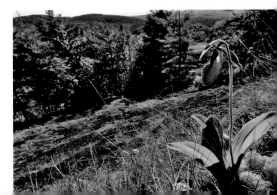

Equipment

Technique

SHOOTING

95

Creative Effects

Editing Workflow

Reference

TOP LEFT

These spring beauties were photographed with a 105mm macro lens. The aperture was mid-range at $f/8$ to keep the sharpness where I wanted it in the flower, but left the surrounding flowers soft to frame the center blossom with color. 105mm macro (APS); ISO 200; 1/1000 sec at $f/8$.

BOTTOM LEFT

Working with an 8mm extension tube on a 20mm lens let me almost touch the blossom with the lens for great close-up sharpness and detail. 20mm (Full); 8mm extension tube; ISO 100; 1/60 sec at $f/22$.

TOP RIGHT

A reasonably close telephoto shot can bring a number of details together. Shot at $f/22$ to maintain sharpness, at 1/6 sec to soften the water and enhance the reflections. 170mm (APS); ISO 320; 1/6 sec at $f/22$.

ABOVE

Snowflakes on grass. Shot with a 24mm lens mounted backwards with the threads screwed onto a reverse lens adapter. 24mm lens with reverse lens adapter (APS); ISO 200; 1.3 sec at ƒ/22.

ABOVE

Using the 8mm extension tube on a fixed 24mm lens with an adjustable aperture ring gives a unique perspective on the landscape. 24mm lens with 8mm extension tube (APS); ISO 250; 1/2 sec at ƒ/22.

Another macro option is to work with a reverse lens adapter. The adapter is placed on the camera lens mount, then the front of the lens is screwed onto the filter threads on the reverse adapter. Since magnification increases with shorter focal lengths, experiment with lenses from about 20 or 24mm to 50mm. The shorter the focal length, the greater the magnification. This method requires the use of a prime or zoom lens with an aperture ring, so the aperture can be adjusted manually since it is not directly coupled to the camera's body.

Adding a thin extension tube to a 24mm, 20mm or shorter focal length lens adds even more possibilities by turning it into a wide-angle macro lens. At ƒ/22 there will be reasonable depth of field for a very close subject, plus a soft focus background that helps offer a sense of place. There are no contacts on the 8mm extension tubes, so this also requires a lens with manual focus and an aperture ring. A 24mm lens works nicely for both the 8mm extension tube, as well as high magnification macro with a reverse lens adapter.

Lighting for macro close-ups can be enhanced with compact portable reflectors or special ring flashes that can be used on the front of a lens to eliminate shadow and shutter speed issues. Use a very sturdy tripod, cable release, and mirror lock-up, and be prepared for longer exposure times in natural light. Because of the subject magnification, the air has to be very still for long exposures.

LEFT

Working with a long telephoto lens isolates details and assures a soft background. I used a 70–200mm zoom with a 2× teleconverter at maximum focal length to shoot this birch tree detail about 400 feet away. 400mm (APS); ISO 400; 1/60 sec at ƒ/5.6.

ABOVE

Working with a wide-angle lens at close focus distances gives a broader field of view as well as extended depth of field so all the details are in focus. The background was misty, so there were no distracting details. 14mm (APS); ISO 200, 1/15 sec at ƒ/22.

Energy and Emotion

There are many different ways to create a feeling of energy or emotion in a photo. While the feeling of energy often comes from action and subjects in motion, emotions can be tied to color, tone, details, and subject composition.

In science class, we learned energy is classified as either kinetic or potential energy—kinetic energy is the energy of a subject in motion, while potential energy is the energy stored in an object that has the potential to move. In the field, I apply these principles to portraying energy in a photo.

A rollercoaster at the very top of a drop is bursting with mostly potential energy, something that changes to kinetic energy at the bottom of the drop. If you take your photograph at the moment when the rollercoaster begins to fall, there is a sense in the image of both the potential and kinetic energy present. This gives the impression of motion even though the

exposure "stopped" the action in the photograph. If the coaster was blurred in the image, you would still sense the motion, but perceive it in a different way, since the passengers would also be blurred. Panning on the moving coaster would also show motion, but the details of the track would be lost. Every situation is different and every style of shooting gives its own effect, but to help yourself come to grips with motion, it helps to think about the potential and kinetic energy of each subject in a photo.

BELOW

Every part of this evocative image has its own unique energy. The soft sun and clouds, flowing valley mist, silhouetted tree detail, and power of the majestic mountains combine to create a peaceful scene that inspires a positive emotional response. Noblex panorama camera; ISO 100; 1/4 sec at f/11.

LEFT

Potential and kinetic energy at their finest—just going into free fall on the first steep drop in a classic wooden rollercoaster. You can almost feel the weightlessness even though the action in the photo is completely stopped. This photo will most likely trigger an emotion as well! 180mm (Full); ISO 100; 1/400 sec at f/8.

ABOVE

This image is about the motion, made stronger by the contrast with the stillness of the birds. The wave near the top adds an energetic dimension throughout the image that would be missing had it been lower in the composition. The 1/5 sec exposure offers a sense of energy without losing too much detail. 112mm (APS); ISO 100; 1/5 sec at f/22.

BELOW LEFT

The 1/30 sec exposure kept most of the sharpness, but allowed just enough motion so it almost feels like you are looking at a video. 24mm (Full); ISO 100; 1/30 sec at f/22.

BELOW RIGHT

The inquisitive energy of the puffins draws you in—it's hard not to smile and wonder what they are up to. 110mm (APS); ISO 800; 1/320 sec at f/14.

Equipment

Technique

SHOOTING

99

Creative Effects

Editing Workflow

Reference

OPPOSITE

Just playing around one day, I thought I'd take photos of some feeding mallards. This was one of the more enjoyable images I shot. 70mm (Full); ISO 100; 1/60 sec at ƒ/11.

LEFT

There's a very dynamic quality to this fish-eye composition. The strong colors, contrasts, and curved horizon lines create a very energetic and evocative image. 16mm fisheye (Full); ISO 100; 1/30 sec at ƒ/4.

The basic emotions include love, joy, sadness, surprise, anger, and fear. I find it's helpful to first feel the emotion that you are working to portray in a photo. If necessary, take time to tune in to the emotion—examine the scene to find the details that are creating the emotion and then compose the image around those details.

Shades of red and blue are energetic colors, while green tends to be relaxing. The colors of a brilliant sunrise or sunset are especially stimulating. Animals and people can bring both energy and emotion to a photo, especially when you anticipate their actions and key in on their expressions and reactions.

Fine Art Imagination

Some images have the ability to transcend time and space, touching us in a unique way. Rather than simply being well executed images, they touch our soul, and ask questions without giving answers or making statements. Rather than telling us, "You are here!," they ask "Where are you, and why are you here?"

Fine art has as many different interpretations as there are people. Personally, I feel fine art photographs let us feel the mood and mystery created within a subject, rather than portraying specific locations and information. The images are about textures, colors, and mood, including an element of mystique that shows us details and patterns in a way we might not have comprehended before.

Creating a fine-art photo is a wonderful challenge. Fine art is about well-composed lines and patterns with a wonderful balance of details and light, and is generally sparse on information. The image has just enough details to draw you in, and just enough space to let you wander between the lines.

LEFT
Ice patterns over moving water are quite dynamic. Subdued light allowed me to shoot a fairly long exposure, which softened the water detail and turned the image into a study of contrasts, lines, and details. 18mm (APS); ISO 100; 1/2 sec at ƒ/22.

LEFT

The late afternoon sky had turned misty when I started experimenting with panning the length of the grasses growing along the edge of the small lake. Photoshop helped enhance the soft twilight background reflected in the calm water. 200mm (APS); ISO 500; 1/5 sec at ƒ/13.

BOTTOM LEFT

I just barely noticed the sun when it first appeared, very soft and subtle in the clouds, still rising above the distant horizon. I worked quickly to adjust the camera on the tripod and to frame the shot. It seemed only seconds more before the sun became much brighter and this otherworldly effect had disappeared. 150mm (APS); ISO 200; 1/30 sec at ƒ/11.

BOTTOM RIGHT

The colors, contrasts and details in this scene caught my eye and drew me to create this photo. I like the energy of the colors and contrasts, and was intrigued by the abundance of freshly fallen petals from the tree that was shadowing the tulips. 20mm (APS); ISO 200; 1/5 sec at ƒ/22.

Equipment

Technique

SHOOTING

103

Creative Effects

Editing Workflow

Reference

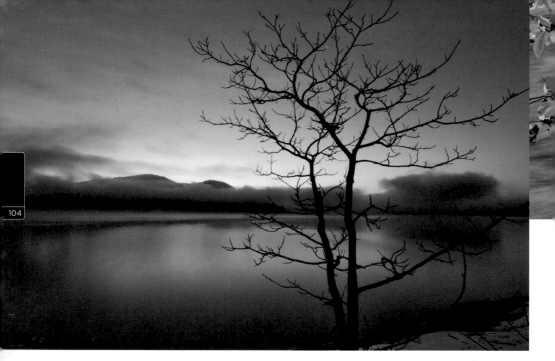

ABOVE

The long exposure softened all the water and mist detail, contrasting with the sharp tree silhouette in the foreground. The gentle transition in the twilight on the horizon draws the eye from foreground to background. The mist adds mystery and mood in this landscape that is really more about art and mystique. 14mm (APS); ISO 100; 30 sec at ƒ/22.

BELOW

It was a calm morning and the mist had just broken, hanging above the quiet water of the bog. 150mm (Full); ISO 100; 1/60 sec at f/22.

BELOW

While this image may border on being more about the subject, I am drawn to this photo by the mystical effect of the lines, textures, and contrasts, and the seemingly eternal qualities of these enormous ancient cedars. 28mm (Full); ISO 100; 1/2 sec at f/22.

ABOVE

The soft color contrasts behind the still branch bring a richness and life to this image. The patterns, textures, colors, and sharp detail of the branch create an invigorating image that keeps the eye moving all through the photo, from the foreground sharpness to the vitality of the background. 112mm (APS); ISO 320; 1/10 sec at f/16.

The photograph might also be about what you can't see when the image is taken. In addition to working with lines of motion, the relatively narrow dynamic range of the camera will create greater contrast in situations where we see only subtle differences.

When working with a digital camera, we can review images to see which ones come close and then create additional photos that build on and refine the desired effect. Fine-art photos are often created more with intuition and feeling, rather than knowing that you "got the shot."

Fine Art Tips

- Simplify composition to the essential details.
- Look for a shot with reflections, color, light, and details, as well as contrast, mood, and mystery.
- Compose an image around the subject rather than the obvious.
- Work with longer exposures to intensify colors and add mood, contrast, and motion lines.

A Sense of Place

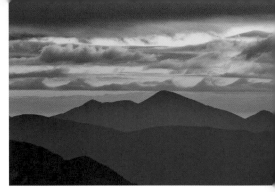

A photograph that evokes a sense of place is a fine art photograph that's as much about a location as it is about the mood and mystery within the image. Details provide information about the space, but the light, composition, and mood evoke a greater power and bring a timeless feel to the scene, portraying the spiritual essence of a location.

The details may be subtle or bold, but there is a quality to the image that transports a person into the magic of that location. It offers the feeling of being there and speaks about a place in a way that captures its innate grandeur, or humility. There is harmony in all the details, yet the overall feeling is somewhat mystical.

A sense of place is "felt" more than it is perceived, and is often a result of everything coming together rather than keeping every compositional detail in its place. This kind of image reflects a special quality and mood of light that's related to the feel of the landscape. It's not necessarily shot in the magic hour or in specific weather, but it does represent a perfect balance of composition, details, light, and camera techniques.

ABOVE

This landscape borders on the feel of fine art, but there are enough mountain details to pull you into the landscape and make the viewer feel as if they are on a summit, watching the light fade behind the clouds and mountains. 200mm (APS); ISO 200; 1/50 sec at ƒ/9.

BELOW

Well past the morning magic hour of light, the combination of landscape details, reflections, 3D feel, and lighting work together for this composition. Perhaps it's the Hornbeck Blackjack canoe that has a grounding effect, pulling the viewer into the image and evoking a sense of place. Seitz Roundshot panorama camera; ISO 100; 1/60 sec at ƒ/22.

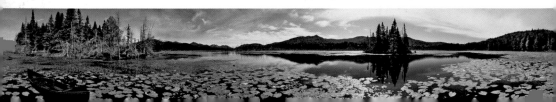

Equipment

Technique

SHOOTING

107

Creative Effects

Editing Workflow

Reference

ABOVE

While the landscape details aren't enough to define a specific location, the strength of the foreground details—the water reflections and clouds—have a way of pulling you into the composition and putting you there. 11mm (APS); ISO 200; 1/10 sec at *f*/14.

LEFT

This is a classic afternoon scene in the Rockies. Thunderstorms have passed by, hanging over the next mountain range with the sun glowing on the landscape. For those who know the region, this mountain defines the location as Montana's "Big Sky Country." 175mm (Full); ISO 100; 1/15 sec at *f*/16.

ABOVE

There were magical qualities to the soft clouds and color tones of the pre-dawn light over Frenchman Bay near Acadia National Park. It's the lobster boat and buoys though that give the image a sense of place. 150mm (APS); ISO 250; 1.3 sec at *f*/9.

Sense of Place Tips

- Portray the scene through the finer details and subtle nuances.
- Ask yourself, "What details make this location unique and special?"
- Compose the photograph around the unique features and details of the landscape.
- If the location works, but the light doesn't, think about what might help and make a note to return in better conditions.
- Focal length is not as important as the light and simplifying composition to the essentials.

Weather

Understanding the weather and having an idea of what to expect in changing weather situations helps "put you in the right place at the right time." Having a sense of how the weather might change can also make the difference between packing up and leaving, or staying a little bit longer and getting some extraordinary photos.

With up-to-date weather and satellite imagery available on the Internet, it's easy to check potential conditions before heading out for a shoot. Understanding old-fashioned weather lore can be helpful for deducing the type of weather that may occur in light of the current weather conditions.

Water can be a solid, liquid, or gas. As moisture builds in the air through evaporation, warmer air can hold more water vapor than cooler air. As warm air rises, its pressure and temperature decreases, causing the relative moisture level to increase. When the relative humidity exceeds the saturation point (dewpoint), excess moisture condenses into tiny water droplets and creates clouds. As valley air settles and cools overnight, fog, dew or frost can occur.

If there is enough excess moisture in the atmosphere, it may come down as rain or snow. If rain falls into sub-freezing temperatures near the ground, it becomes freezing rain and coats everything with ice. If it freezes in a cold layer higher up, it lands as sleet. Hail forms when raindrops are blown up and down through alternating freezing and wet sections of storm clouds, adding layers and size before falling to the ground.

Weather is a result of the interactions of the sun with the land and large bodies of water. Weather systems that form can be hundreds of miles across, or as small as a thunderstorm, and generally move west to east around the globe.

BELOW

A thick fog layer filled in the valley all around the mountain. The rosy sunlit clouds overhead at sunrise, plus the valley fog, indicate low pressure moving in. Noblex panorama camera; ISO 100; 1/30 sec at f/11.

BELOW RIGHT

Capturing a nice full stroke of lightning with just the right composition balance is really up to the luck of the draw. This was photographed in evening light so there is still ambient light on the landscape. The few tiny raindrops that had fallen on the front filter add to the effect. 20mm (APS); ISO 800; 2.5 sec at f/32.

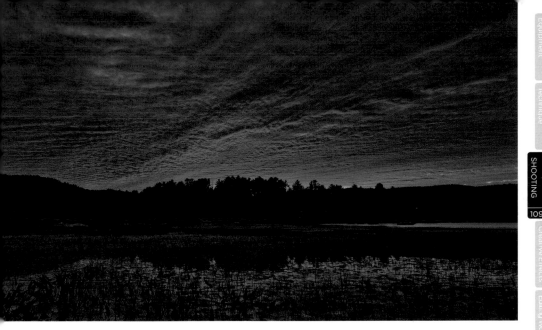

A low-pressure system in the Northern Hemisphere is composed of relatively warm, moist air that rises and spirals in a counter-clockwise motion. A high has clearer, cooler, denser, sinking air that rotates clockwise around the center of highest pressure. The warmer moist air in a low cools as it rises, forming clouds and precipitation that circulates toward the colder air of a high and spreads out over the cooler, drier air.

ABOVE

Red sky at night, a sailor's delight... Evening clouds don't get any redder than this. The next day dawned bright and clear. 20mm (APS); ISO 200; 1/15 sec at f/5.6.

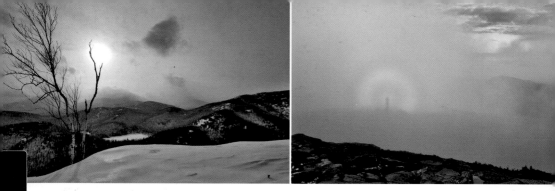

ABOVE

A snow sky tends to have a smoother, more diffuse, and lighter gray color than a rain sky. The sun shines through with a very soft, almost surreal brightness around itself in the cloud cover. 13mm (APS); ISO 320; 1/500 sec at f/16.

ABOVE

The Specter of the Brocken is from my shadow on the cloud, which is surrounded by a brilliant circular rainbow "glory." 35mm (Full); ISO 100; 1/30 sec at f/11.

Mountain ranges and large bodies of water can affect local weather and create their own localized weather patterns. Air traveling over water becomes more saturated with water vapor which may fall as rain or snow when it chills over a relatively colder land mass, causing "lake effect" precipitation. Air pushed up over mountains cools as the air pressure drops with the elevation gain. It forms clouds and rain or snow when the moisture content is high enough. Air traveling down the opposite leeward side will be warmer and drier than on the windward side.

Before heading out on a shoot I check satellite views and weather to have a sense of what conditions might occur. In the field, I am constantly evaluating light, cloud formations and movements. Even if it's overcast, I look for changing color tones in the sky to get a sense of whether the clouds may be clearing or getting more dense. While it's possible today to electronically get current weather in the field, local conditions may be completely different from those in the reporting station some miles away.

Predicting the Weather

Red sky in the morning, sailors take warning: The sun shining through the clear air of the passing high, shines on and colors the advancing cirrus and lower, thicker stratus clouds of a low, warning of precipitation within 12–24 hours.

Red sky at night, sailors' delight: The leading edge of cool, dry high-pressure air has pushed in under the moist air of the departing low. There is great color and light on the remaining clouds overhead with the sun setting in the clearer air of the approaching high.

Some of the highest clouds are wispy cirrus clouds that are composed of ice crystals. When the sun shines through a quantity of these crystalline clouds, "sun dogs" and large halos can appear. These often predict precipitation within 12–24 hours since the cirrus clouds often travel ahead of a low.

In a very dry air, jets leave no visual contrail. If a jet has no contrail overhead, but leaves one in the western sky, moister air is moving in. Cirrus clouds followed by lower thicker layers of stratus clouds are a pretty sure sign of a low and precipitation moving in within 12–24 hours.

When the direction the wind is blowing from shifts from the northeast, east, or south to the north or west, it signals clearing weather as a high moves in. As winds shift from the north, west, or calm to the south or east, it signals a change to a low moving in.

LEFT
If the sun is low enough in the sky and shining through clear air just after a storm passes, you can be almost assured of seeing a rainbow. 20mm (Full); ISO 100; 1/15 sec at ƒ/16.

Equipment
Technique
SHOOTING
111
Creative Effects
Editing Workflow
Reference

Tips to Remember for Assessing Weather in the Field

- Cloud caps forming over mountains typically indicate precipitation within a few hours.
- Snowfall changing from crystals to needles indicates that warmer air is aloft and that precipitation will change to rain.
- Fairly heavy fog often forms overnight in a valley before rain. If this happens in the winter it indicates rain coming rather than snow.
- Dew and frost rarely form as a high moves in, but occur frequently as a high moves out and a low moves in.
- Sun dogs (rainbow-colored bright points of light in high clouds either side of the sun), or halos around the sun or moon, predict a low moving in.
- Keep an eye on jet contrails and where they are in the sky. The thicker and longer lasting the contrail, the greater the moisture in the air.
- Learn about local weather conditions. For example, some mountain ranges have regular afternoon thunderstorms and it's best to be off the mountain before they become active.

Tips for Photographing Lightning

- Personal safety is paramount! Lightning can strike up to several miles from a storm.
- Properly exposed lightning photos depend on the aperture size/ISO in relation to the brightness and proximity of the lightning flash. Experiment with ISO 200 and f/16 to start, and adjust as needed.
- The length of exposure depends on the brightness of the landscape. Even with a dark storm, daytime exposures will be relatively short.
- Use a specific shutter speed, or the bulb setting—depending on available light and camera settings. Evening is a particularly good time to shoot, since you still having enough light for landscape detail, and exposures can be longer for a better chance at catching the lightning.
- Longer exposures may capture more than one bolt.

ABOVE

Mist forms when there's enough temperature difference between the air and water. If the air has a lower relative humidity, the mist will evaporate once it rises, giving a more mystical appearance to the scene. This happens more often in late summer and early fall, but can occur throughout the year with the right conditions. 112mm (APS); ISO 320; 1/0 sec at $f/22$.

LEFT

Everything around the bog was coated with a beautiful layer of frost. Note the high cirrostratus clouds in the sky that occur as a low is moving in—which also coincides with a heavy frost or dew. 20mm (Full); ISO 100; 1/8 sec at $f/22$.

Rainbows, Glories, and Light Shafts

- Rainbows occur at an angle of 42 degrees from the direct line of sight opposite the sun—the sun has to be low enough in the sky for a rainbow to appear above the horizon.
- The intensity and number of visible rainbows depends on the size of the water droplets in the air.
- Fogbows can occur when the bright sun is behind you, and denser fog is in front. (Moonbows, or lunar rainbows, are also possible.)
- When the sun is reasonably low in the sky on one side, and mountain mists are hanging just off the summit on the other, it may be possible to view the shadowy Specter of the Drocken (a massive, shadowy image cast by the observer and projected on mists above a mountain-top) in the mists, which is even more fabulous if there is a rainbow "glory" surrounding it.
- Exposure for rainbows and glories can be based on the average meter reading or perhaps slightly overexposed—but bracket to be sure you get it just right.
- Sun pillars can occur above the sun at sunrise or sunset if there are just the right quality of ice crystals in the air. From mountaintops, they may be shining down into a valley once the sun is higher.
- Sun shafts (crepuscular rays or "God's rays") occur when the sun is shining through air with high levels of moisture and/or aerosols and dust. Expose for the average reading and bracket to capture both highlight and shadow detail for later HDR work.

A concise general guide to weather prediction can be found on the Web at www.ussartf.org/predicting_weather.htm.

Some great photos of clouds and other atmospheric phenomena can be found at www.cloudappreciationsociety.org.

Equipment

Technique

SHOOTING

113

Creative Effects

Editing Workflow

Reference

The Four Seasons

Whether in the desert, tropics, mountains, or a city, there are naturally occurring cycles of life that offer a wide variety of seasonal photographic opportunities. While the tropics and sub-tropics have basically two seasons—wet and dry—most temperate areas of the world enjoy the wide variety of changes that take place in the four seasons.

Being a keen observer provides some great photo opportunities, but knowing what to look for helps put you in the right place at the right time. It's good to know what can happen in different weather conditions, in addition to various ecological events such as flower blooms, migrations, fall colors, as well as the differences according to elevation and region. When researching, remember to check for special sites, such as bogs, heaths, barrens, areas of old growth, and other unique habitats.

Knowing what to look for comes from years of being observant, as well as doing research with field guides, regional information centers, gardens, and natural history museums. Many localities have events and festivals that are planned around natural events. Different land preserve groups, including Audubon and The Nature Conservancy, plus national and state parks, monuments, and wildlife refuges, protect the more unique habitats. Information on these as well as reports on local flower blooms and other events can often be found on the Internet.

RIGHT

Spring blooms can include mountain laurel, wild azaleas and rhododendron. Composing the image around the flowers helps evoke a sense of the season. 24mm (Full); ISO 100; 1/8 sec at f/22.

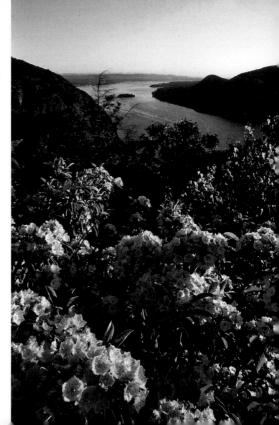

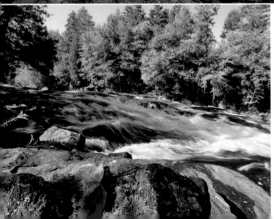

Equipment

Technique

SHOOTING

115

Creative Effects

Editing Workflow

Reference

TOP, LEFT TO RIGHT

Be sure to explore when in new locations. While millions of people visit Niagara Falls, many fewer see the beauty of the Niagara Gorge. 24mm (Full); ISO 100; 1/8 sec at f/22.

Soft light, spring greenery, and birch tree detail. 70mm (APS); ISO 100; 1/50 sec at f/8.

As spring melted the ice pack along the shores of Cape Breton, the wind blew it onto the shores, rounding the rough edges into ice "cobbles." 24mm (Full); ISO 100; 1/4 sec at f/22.

An idyllic summer day often has a wonderful quality of light in the moist air of late afternoon. 18mm (APS); ISO 200; 1/60 sec at f/20.

ABOVE

Fall colors are quite spectacular in the Northeastern United States because of the diverse mix of hardwoods. Seitz Roundshot panorama camera; ISO 100; 1/60 sec at f/16.

LEFT

One of the first fall leaves adds a nice touch of color to the late summer green at Buttermilk Falls. 10mm (APS); ISO 100; 1/8 sec at f/22.

ABOVE LEFT
I used a 24mm lens and an 8mm extension tube to get this close-up of rainbow cactus blossoms. 24mm with 8mm extension tube (Full); ISO 100; 1/60 sec at *f*/22.

ABOVE CENTER
Ice builds up around rocks and hangs off overhead branches after the first really cold nights of winter. 20mm (APS); ISO 100; 1/8 sec at *f*/22.

ABOVE RIGHT
Windblown mountain summits build feathery fingers of rime ice that can glow in the morning or evening sun. 24mm (Full); ISO 100; 1/15 sec at *f*/22.

Spring flower blooms happen almost everywhere, from along the waterways in the valleys to the alpine mountaintops. In temperate zones there is generally a succession of flowers blooming from early spring up to the time the ground freezes in fall. In wooded areas, spring flowers can carpet the ground in certain locations, but these locations are generally more isolated. With optimal weather conditions, flower blooms can be quite spectacular even in the desert, covering almost every bit of ground with a variegated carpet of perennials and annuals.

There are wonderful subtle transition periods between the fresh soft colors of spring, the greens and blues of summer, the brilliant colors of fall, and the white stillness of winter. In late spring, leaves have filled out, but are still a pale color that contrasts with the darker conifers. As summer blends into fall, wetland shrubs and a few individual trees turn first, contrasting brightly with the still mostly green landscape. Occasional frost adds a delicate icing to leaves, grasses, and flowers for some wonderful close-up photo options. As winter's cold takes over, ice forms on puddles, streams, and along the edge of ponds and lakes. Ice "bells" hang on branches along the edge of streams and windblown lakes. All of these transitional conditions may only last a couple of days before the next season takes over completely.

While it's fun to travel, a good place to start learning about the changing seasons is the place you know best—your own backyard. The more you explore and observe the subtle changes, the better prepared you'll be to find and appreciate the effects elsewhere. It takes time to tune in to the details of your surroundings. Carefully observe what seasonal details are visible—ice, snow, tree leaves or buds, flowers, wildlife. These are details that can be worked into photos wherever you go.

ABOVE

Looking for details of the season—like these milkweed puffs—can lead to some great photo opportunities. 24mm with 8mm extension tube (APS); ISO 200; 1/50 sec at ƒ/22.

TOP RIGHT

White pine needle detail on a summer morning through a telephoto zoom lens. 150mm (Full); ISO 100; 1/30 sec at ƒ/8.

RIGHT

Seasonal details aren't always where you normally think of looking for them. Keep looking in every direction around you—up, down, and sideways! 46mm (APS); ISO 200; 1/50 sec at ƒ/11.

Equipment

Technique

SHOOTING

Creative Effects

Editing Workflow

Reference

Daylight Locations and Lighting

Landscape photography encompasses all kinds of environments, including urban, suburban, rural, mountain and water. Infinite lighting combinations enhance all kinds of landscapes and details. While every region and locality naturally has its own unique lighting conditions, there are basic principles of light that can be applied to landscapes everywhere.

There are many different kinds of light; direct, indirect, reflected, clear and sharp, soft and diffuse, filtered, and flat. Landscapes can be front-lit, side-lit, or backlit, or have a soft overall glow. Lighting intensity and tone changes constantly through the day, varying with the base elevation, angle of the sun, and atmospheric conditions. Each type of lighting enhances different subjects in different ways and affects how they appear in relation to other details in the image. The challenge is in discovering the lighting that works for the subject, or, alternatively, finding the subject that works with the lighting.

It's also important to maintain a perspective on the quality of light. I watch light on the landscape all the time and really enjoy watching the subtle changes. The angle of the sun, moisture in the air, clarity of the atmosphere, ground elevation and altitude, and the abundance and type of clouds all affect the quality of the light. Light can be rich and luxurious, or it can be completely gray and flat. Both the quality and intensity can change in seconds, especially when the sky is just starting to break up after a storm.

A general rule of thumb to work by is that when it is cloudy, photograph the detail and textures, and if it is sunny work the open landscapes. When lighting is soft and diffuse, I like working in the woods and along waterways, looking for

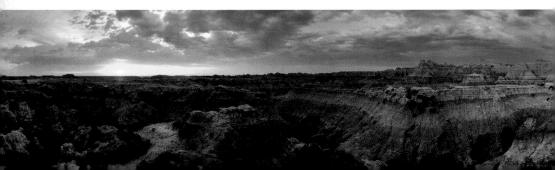

detail, motion, and texture photos that are tougher to capture in high-contrast light. In sunny conditions I work more in the open, looking for energetic landscapes that will be enhanced by the brighter light and sharper shadows, that have vibrant subjects, lines, details, and clouds.

There is always something to photograph in all types of light and conditions. The key is finding the unique details wherever you are. Although some situations are more challenging than others, there is always the potential to find a great photo.

Lighting Tips

- When it's overcast, work the detail.
- If clear and sunny, work out in the open.
- Keep an eye on the quality of light.
- Choose the light for the subject and/or choose the subject for the light.
- Take advantage of the quality of light and lower dynamic range of magic-hour lighting.
- Overexpose misty, foggy, snow-covered, or beach landscapes by about a stop.
- Bracket whenever there is any question about capturing the full dynamic range.

BELOW LEFT

Badlands National Park, as with many higher elevation western US locations, has wonderful clarity to the air, which makes for some great sunrise/sunset and magic-hour conditions. However, the landscape becomes extra contrasty and details become flat once the sun gets higher in the sky. Seitz Roundshot panorama camera; ISO 100; 1/4 sec at f/16.

BELOW

This extra wide-angle view balloon shot features side lighting as well as front lighting, plus the slightly brighter glow you see sometimes directly opposite the sun. 10mm (APS); ISO 200; 1/160 sec at f/8.

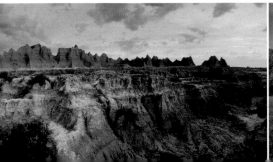

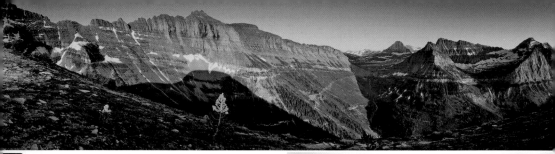

Magic-hour Light

Light changes throughout the day from sunrise to sunset. From the time the sun breaks over the horizon you are dealing with direct light. At first it highlights the highest points, then gradually fills in the valleys, bathing the whole landscape in light. When the sun is lower than 10 degrees above the horizon, the light is filtered by a greater amount of atmosphere and has a warmer tone. The light is softer and has less dynamic range, making it easier to capture the full tonal range in both the highlights and the abundant shadows. Magic-hour light is often the best light of the day, and occurs both morning and evening. The higher the elevation, the greater the clarity of the light.

ABOVE
The first and softest light of the magic hour, highlighting the summits of the Adirondack High Peaks. 24mm (Full); ISO 100; 1/4 sec at f/22.

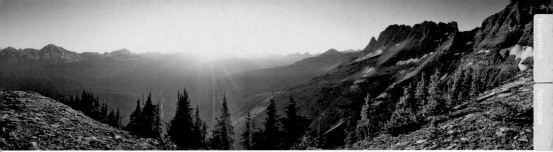

ABOVE

The clarity of the high elevation air in Glacier National Park, MT, keeps the light and shadows pretty intense, even near sunset. Seitz Roundshot panorama camera; ISO 100; 1/40 sec at f/16.

LEFT

Late afternoon light accentuates the mountain detail in this photo taken at Cades Cove, Great Smoky Mountains National Park, NC. 180mm (Full); ISO 100; 1/60 sec at f/16.

Front, Side, Back, and Soft Light

LEFT

The soft low light coming from the side helped add depth to this shot with the shadows accentuating the detail. 55mm (Full); ISO 100; 1/50 sec at ƒ/11.

ABOVE

The soft misty light of morning after a rainy night was perfect for photographing detail at the National Car Show in Lake George, NY. 16mm (APS); ISO 200; 0.6 sec at ƒ/16.

RIGHT

This backlit photo was exposed more for the highlights to help silhouette the lobsterman and boat in Camden, ME. 70mm (APS); ISO 200; 1/1000 sec at ƒ/8.

FAR RIGHT

Although the sun is slightly off to the side, with it higher in the sky it has a front-lit effect. The sculpture sets off the front from the back and the clear sky adds a cheery effect to the detail of New York City and the Brooklyn Bridge. 35mm (Full); ISO 100; 1/60 sec at ƒ/22.

Equipment

Technique

SHOOTING

123

Creative Effects

Editing Workflow

Reference

Midday Light

As the sun gets higher in the sky, the light becomes more intense and contrasty with a greater dynamic range. Brighter areas will record as white and darker areas will be black. It's important to bracket to pick up both highlight and shadow detail for doing HDR. When the sun is higher in the sky I appreciate having some clouds to add interest, details, and shadows. A polarizer can help accentuate tonal contrasts, as can digital enhancements.

ABOVE

Clouds add some great detail and interest on a bright sunny day. Noblex panorama camera; ISO 100; 1/125 sec at f/16.

RIGHT

Overexpose by one or two stops when photographing directly into the sun with evaluative metering—and remember to bracket! 10mm (APS); ISO 100; 1/60 sec at f/16.

FAR RIGHT

I found the right angle for this tall waterfall to catch rainbow colors from the bright sun behind me. 200mm (APS); ISO 200; 1/30 sec at f/22.

Equipment

Technique

SHOOTING

125

Creative Effects

Editing Workflow

Reference

Reflected Light

Reflected light has the hue of whatever subject the light is reflecting from. It could be the color of sunlit fall leaves in reflections on the water, or the soft warm glow from a redrock canyon wall reflecting light onto shadowed areas of an opposite wall. When photographing actual reflections, remember the focusing distance for the subject in the reflection is the actual distance from the camera to the subject—not the distance from the camera to the reflecting surface.

TOP LEFT

An ultra wide-angle lens has the depth of field needed to capture detail in the puddle and rock, as well as the far shoreline and clouds. 11mm (APS); ISO 100; 1/5 sec at ƒ/22.

LEFT

I set this image up by hyperfocusing so both the window pane frost and the reflection of the building are in sharp focus. 35mm (Full); ISO 100; 1/20 sec at ƒ/22.

Equipment

Technique

SHOOTING

127

Creative Effects

Editing Workflow

Reference

LEFT

Glass-covered buildings that become a mirrored surface are a fun way to work with city details. 150mm (Full); ISO 100; 1/60 sec at f/16.

ABOVE

The best reflections on water occur when trees and other objects on the far side of the river or stream are sunlit and the subject area is shadowed. 200mm (APS); ISO 250; 1/6 sec at f/18.

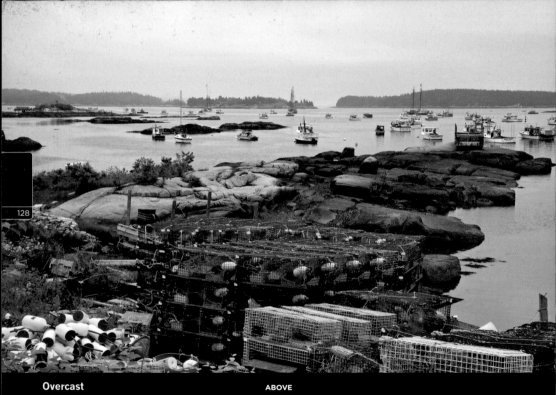

Overcast

ABOVE

While I tend to look for tighter, detail images in overcast conditions, sometimes even open landscapes work well in the soft, moody light that enhances more subtle tones and details. 34mm (APS); ISO 320; 1/4 sec at ƒ/16.

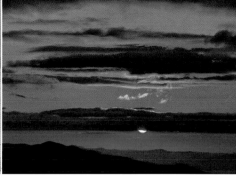

ABOVE

Even though this sun was red to my eye, there was already enough contrast that it shows up closer to white with a single exposure in the camera. I did an HDR composite to bring color back to the sun. 150mm (APS); ISO 250; 1/60 sec at ƒ/11.

ABOVE RIGHT

With only a sliver of the sun showing, this image was shot without any Exposure Compensation. 95mm (APS); ISO 200; 1/500 sec at ƒ/9.

LEFT

The moist, but clear air around a Caribbean Island adds a wonderful quality to a sunset. 40mm (Full); ISO 100; 1/30 sec at ƒ/8.

Sunrise and Sunset

When photographing a sunrise or sunset with the sun in the image, keep an eye on the histogram to see how the sun is affecting the overall metering. Using Evaluative Metering when the sun is in the image, an image will need varying amounts of overexposure compensation and then underexposure compensation once the sun has set. To get the color tones in the sun itself, considerable underexposure is needed for an evaluative metered shot, or spot meter on the sun and overexpose by about a stop. Bracket extensively to get details for the final shot.

Nighttime Locations and Lighting

Once the sun sinks below the horizon, it is about an hour before the light fades completely. At first, the landscape becomes more contrasty since there is no longer direct light on the landscape. The contrasty light is often replaced with a soft, warm glow from the atmosphere and clouds overhead, bringing equilibrium back to the landscape and sky. Lower elevation clouds can be illuminated within minutes of sunset, but it tends to be at least 15 minutes or longer before high elevation clouds are illuminated with a rosy glow.

Soon after the deeper blue edge of the Earth's shadow rises beneath the rosy glow on the eastern horizon, the light slowly changes, and the landscape contrasts with the sky again, black against blue. The first stars appear in the deep blue sky, while any moonlight enhances landscape details.

Both morning and evening also have about a 20-minute period when atmospheric light and city light is in close tonal balance. There is enough ambient light to show building detail, and lights turning on accentuates detail, adding life and color.

Long exposures of traffic can create wonderful lines and swirls of vibrant color. As the atmospheric light fades to deep blue, the scene becomes a starker contrast of bright lights in black buildings against a dark sky.

Night Lights

BELOW LEFT
Some of the best light of the day occurs after the sun sets and light on the landscape and artificial lighting are in close tonal balance. Lake Placid, Adirondack Park, NY. Seitz Roundshot panorama camera; ISO 100; 1 sec at f/8.

BELOW RIGHT
Comet Hale-Bopp and the Aurora Borealis, Adirondack Park, NY. 50mm (Full); ISO 100; 30 sec at f/1.4.

Equipment

Technique

SHOOTING

131

Creative Effects

Editing Workflow

Reference

In-between Light

TOP LEFT
The high clouds overhead are still illuminated, while closer to the horizon they are within the Earth's shadow line. The lower elevation clouds have a "silver lining" that occurs during early twilight. 11mm (APS); ISO 200; 1/10 sec at ƒ/8.

CENTER LEFT
Low light allows for longer exposures that soften any motion. 10mm (APS); ISO 400; 13 sec at ƒ/8.

ABOVE
A wonderful glow over Lake George about 20 minutes before sunrise. 27mm (APS); ISO 200; 1/5 sec at ƒ/8.

BOTTOM LEFT
The soft glow before sunrise provides some of the best light of the day in desert areas where there is low atmospheric moisture. Death Valley National Park, CA. 200mm (Full); ISO 100; 1 sec at ƒ/8.

Twilight

ABOVE LEFT
The afterglow in the sky reflected in the water. 200mm (APS); ISO 320; 1/8 sec at $f/5.6$.

ABOVE CENTER
The first light of day during the Leonid meteor shower. 24mm (Full); ISO 100; 50 sec at $f/2.8$.

ABOVE RIGHT
The stars were shining brightly in the last bit of twilight blue in the eastern sky. 20mm (APS); ISO 400; 30 sec at $f/4$.

Night Photo Tips

- CMOS sensors are best for very long exposures and longer battery life.
- Start out with a fully charged battery. Note that the LCD and autofocus both represent power drains.
- Work with the Exposure Value Chart when it's too dark for the camera's light meter.
- Use a tripod and remote cable release with the camera on Manual/Bulb mode for exposures longer than 30 seconds.
- Turn lens stabilization off and use mirror lock-up for telephoto shots.
- If shooting Raw, use auto-white balance, if JPEG try the sun setting or experiment with auto or other settings for various color tones.
- Focus on a distant light or high-contrast object if autofocus works and then turn autofocus off. Or focus manually, highlighting an object with a flashlight to focus on. The Infinity setting often varies slightly at different zoom focal lengths, so check and adjust with that while it's still light.

- With Evaluative Metering, expose for the color tones of the glow on the clouds to pick up the red colors of sunset/sunrise. Underexpose to get the deeper blue tones of twilight.
- Long Exposure Noise Reduction doubles the time of the exposure (as it is the time taken to expose plus the time for dark screen processing). To save time it is possible to disable long exposure noise reduction and apply noise reduction in post-production.
- The virtual horizon feature can be used to level the camera.
- Work with the rules of depth of field and hyperfocal settings when including foreground details.
- Use a lens hood and/or a pocket warmer or small fan to protect the lens glass from a coating of dew or frost during long night exposures.
- Check on any copyright or trademark issues for commercial photo use of well-known buildings and locations.

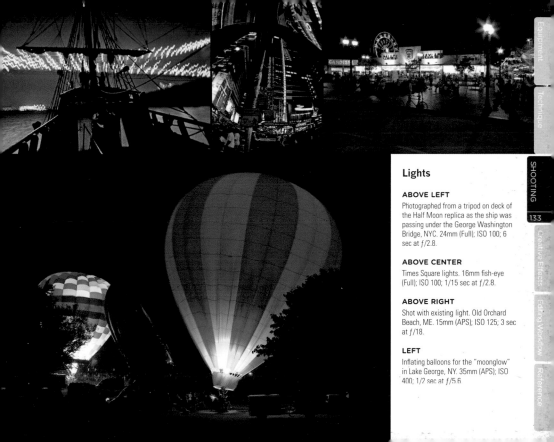

Equipment

Technique

SHOOTING

133

Creative Effects

Editing Workflow

Reference

Lights

ABOVE LEFT

Photographed from a tripod on deck of the Half Moon replica as the ship was passing under the George Washington Bridge, NYC. 24mm (Full); ISO 100; 6 sec at f/2.8.

ABOVE CENTER

Times Square lights. 16mm fish-eye (Full); ISO 100; 1/15 sec at f/2.8.

ABOVE RIGHT

Shot with existing light. Old Orchard Beach, ME. 15mm (APS); ISO 125; 3 sec at f/18.

LEFT

Inflating balloons for the "moonglow" in Lake George, NY. 35mm (APS); ISO 400; 1/2 sec at f/5.6.

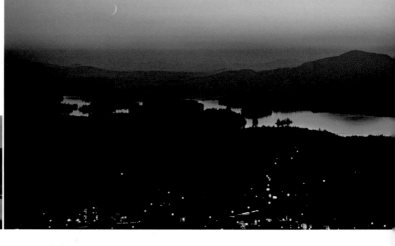

RIGHT

The crescent moon in the glow after sunset, Saranac Lake, NY. 160mm (Full); ISO 100; 1/8 sec at ƒ/5.6.

BELOW

The full moon is within the tonal balance of the landscape for only a brief time after sunset and before sunrise. Lake George NY. 150mm (Full); ISO 100; 1/8 sec at ƒ/5.6.

Mooning

o Since moonlight is reflected sunlight, the "sunny 16" rule still works (1/ISO at ƒ/16). However, since we perceive the moon to be a bright object in the dark sky, an exposure of 1/ISO at ƒ/11 comes closer to what our eye perceives. Check the exposure, bracket, and experiment, especially when the moon is in different phases or close to the horizon.

o Bracket for HDR work to achieve a natural balance between a crescent moon and earthshine on the rest of the moon's disc.

o Use a guideline of 50/focal length (50/100mm = ½ second) as the approx. slowest shutter speed for each focal length to keep the moon from showing motion blur because of the Earth's rotation. Use the mirror lock-up for telephoto shots!

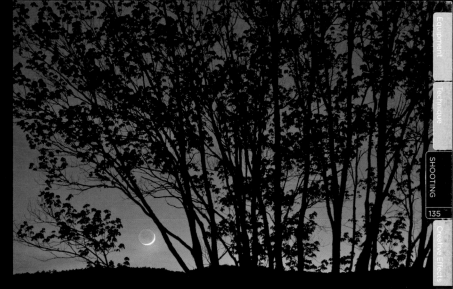

Equipment

Technique

SHOOTING

135

Creative Effects

Ed and Workflow

Reference

TOP

The full moon—1/ISO at *f*/11.

BOTTOM

There is minimal light reflecting from a totally eclipsed moon. This was shot with a Nikon 70–200mm lens plus a 2x teleconverter (APS); ISO 6400; 1/4 sec at *f*/11.

ABOVE

The only way to capture the earthshine effect without excessive digital blooming of the crescent is with HDR.

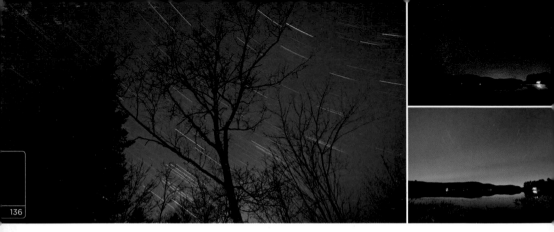

ABOVE

I stopped this long pre-dawn exposure when the sky was just starting to lighten. 11mm (APS); ISO 400; 40 min at ƒ/11.

TOP RIGHT

The Milky Way, North Star, Big and Little Dipper in a clear dark sky over Brant Lake, NY. 11mm (APS); ISO 3200; 30 sec at ƒ/2.8.

ABOVE

Star trails over Brant Lake with some high clouds and light from the quarter moon. 10mm (APS); ISO 100; 62 min at ƒ/16.

Stars and Trails

o To help eliminate star streaking, choose a maximum exposure time of 1000/focal length (1000/20mm = 50 second) to eliminate star movement. Stars rotate around the North Star in the Northern Hemisphere, and the south polar point in the Southern Hemisphere. Motion increases in relation to the distance from the point of rotation. At this maximum shutter speed to stop streaking, stars furthest away from the point of rotation may show slight streaking.

o For good star trails an exposure should be at least a half hour or longer with a wide-angle lens. Less should be sufficient with a telephoto lens. The minimum exposure needed to create a nice trail is about 60,000/focal length (60,000/50mm = 1200 second = 20 minutes)

o Experiment with multiple exposures, dark frames, and stacking software for cleaner imagery. (Search the Web on astrophotography stacking—there is lots of info out there.)

o Meteors seem quite bright, but are hard to record because they pass by quickly. Use a reasonably wide-angle lens with the aperture wide open for sky coverage and try higher ISO speeds (800–3200) to pick up finer meteor trails.

LEFT
Working from a higher perspective some distance away showed the reflections of the fireworks on the water. The foreground trees and background mountain added a sense of place. 90mm (APS); ISO 200; 30 sec at ƒ/6.

ABOVE
The Manhattan skyline is a great backdrop for Fourth of July fireworks. 28mm (Full); ISO 100; 15 sec at ƒ/8.

BELOW
This several-second exposure allowed for the firing of two cannons to be included, adding soft illumination to the rest of the image. 200mm (APS); ISO 100; 6 sec at ƒ/16.

Fireworks and Events

o Fireworks, cannon fire, lightning, and any other flare or flash of light are quite bright and the intensity needs to be regulated by the aperture and ISO. A general guideline is ƒ/11 at 200 ISO. This setting depends on the clarity of the air, and how far and intense the flash is. Check histograms and adjust as needed.

o Work in Manual mode/Bulb with a remote release so you easily control the exposure time and number of bursts that are captured in one frame.

o The multiple exposure feature can also combine bursts on a single frame. Stopping the exposure just before a firework's full bloom shows brighter tips on the flares.

o The actual length of exposure depends on how much light is on the landscape, or how many flashes you want to include if the landscape is dark.

Photographing People

Creating a photograph with a person in the landscape can add perspective, scale, and sense of place. A pure, natural, wilderness landscape may seem untouchable to some, so adding a person helps it become real. Even if the viewer may never find themselves in that situation or location, it brings the photo to a more personal level.

The composition can be about the person or landscape, or be from the perspective of the person or people in the photograph. Photos from behind a person tend to offer their perspective, while photographing from the front or side creates an image that gives the impression of being more about them and the space they live in. It's good to consider these differences in perspective when composing, since it can affect your angle of composition, as well as focal length.

Adding in parts of yourself, either directly or indirectly, draws viewers into the image from your own perspective. Working with your feet in the foreground, or perhaps the canoe you are paddling, adds a human element and helps put the viewer into the photograph.

At events and activities photography is most often about people. People add energy and purpose, giving a feel of what is going on. A city street photo doesn't feel as real without people in it adding life and energy. The key is finding the action, expression, or pose that best captures a sense of the activity or event. Take lots of shots from various angles to have plenty to choose from—especially when people are in motion—and bracket as needed.

ABOVE
This photo is more about the person and the situation, with the subtle landscape details evoking a sense of place. Note how the raised foot position and slight blur gives a feel of motion and climbing. 12mm (APS); ISO 400; 1/100 sec at ƒ/22.

BELOW
You can add yourself into a photo physically, or virtually, with your shadow adding a different dynamic to the composition. 10mm (APS); ISO 400; 1/320 sec at ƒ/11.

ABOVE

This image would be much less dramatic without the scale and perspective added by a person. Noblex panorama camera; ISO 100; 1/125 sec at ƒ/16.

LEFT

The gunners bending away from the blast, add energy and realism to the cannon blast in this reenactment at Fort Ticonderoga, NY. 70mm (APS); ISO 100; 1/30 sec at ƒ/20.

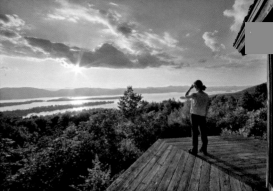

LEFT

This angle on these climbers helps give a feel for the pitch of the climb within the perspective of the landscape. 18mm (APS); ISO 250; 1/200 sec at f/16.

RIGHT

Shot from the perspective of the person, this photo offers a great sense of place. 35mm (Full); ISO 100; 1/30 sec at f/22.

ABOVE

This photo gives the person's perspective as well as that of the overall landscape. Lake George, NY. 10mm (APS); ISO 250; 1/60 sec at f/16.

Equipment

Technique

SHOOTING

141

Creative Effects

Editing Workflow

Reference

ABOVE

The bagpiper walked into the view while I was photographing the fireworks after a French and Indian War reenactment. I recomposed and used a soft fill-flash for foreground detail. 17mm (APS); ISO 200; 20 sec at ƒ/8.

People in the Landscape

- Lighting can be from the front, side, back, or above.
- Think about shooting from high-up, low-down, or eye-level when composing. You can work with LiveView from the ground level, or use it with the camera over your head. Each angle and focal length gives a different feel.
- Use fill-flash (underexposed by about one ƒ-stop or so—experiment for the right amount of detail) to bring detail to a person who is backlit or sidelit, or in a sunset or sunrise scene.
- Create a silhouette by metering for the lighter background around a backlit person. If the silhouette isn't dark enough, underexpose to make the whole image darker.
- I try to work with the action as it's happening to keep a natural unposed look. However, a situation can be posed if need be—or recreated if something looks especially good. Having someone go back and walk through a scene again still gives a natural appearance.
- I like to compose with leading space for people to move into so it feels like they are moving into the view instead of out of it.
- Take lots of exposures since expressions, angles, and positions change quickly, and just a small change in position can make a big difference.
- If in doubt, get a signed model release. A model release is needed for any commercial use of a photo—though not for editorial. It's better to have one than not.

LEFT

Perfect conditions for a New Year's Day Polar Plunge. Snow was falling, people were running in and out of the water, and others were bundled up watching. Shot with a slow enough exposure to slightly blur faster action to help create the sense of motion and energy. 86mm (APS); ISO 200; 1/60 sec at ƒ/9.

Working with Wildlife

Wildlife adds energy, emotion, and mystique to a photo, especially when animals are in their natural setting. Animals all have their own expressions, mannerisms and moods that can be enjoyable, and evocative. Composition guidelines for wildlife are similar to those for photographing people, except you can't ask the animal to pose for you.

Consider whether the photo is more about the animal, the landscape, or the perspective of the animal. Think of the different lighting and angles—backlight, sidelight, or frontlight—and whether to shoot from a high place, low place, or in between. Working with LiveView helps get the camera down to the level and perspective of smaller animals, and works for holding the camera over your head, too.

Long telephoto lenses can be enhanced with teleconverters to get those great "head shots." Try to get as much of the head detail in focus as you can, and be sure the eye is in focus. A flash can add a catchlight to the eye, as long as it doesn't spook the animal. When hand-holding long lenses—stabilized or not—I often shoot in multiples of three or more, so at least one will be tack-sharp.

I especially like to work with wide-angle lenses and portray the animal within the perspective of its surroundings. When composing, be sure to check the viewfinder from corner to corner and notice the size of the animal in relation to everything else in the image. It's all too easy to key in on the animal and not realize how small it appears within the entire frame.

Work from a tripod whenever possible, especially with long telephoto lenses. Turn stabilization off and use Mirror Lock-up or Exposure Delay mode to help get the sharpest shots on a tripod. However, there are situations where you might miss a shot because of the delay, and this will only work if your subject is still. Photograph lots of angles and multiples, and bracket to have plenty to choose from.

LEFT
Even though the moose is a key element in the image, since it is silhouetted and looking away, the image becomes more of a landscape photo. 28mm (Full); ISO 100; 1/30 sec at f/16.

ABOVE AND RIGHT

A blind, whether it is a car, house, or specifically constructed blind, provides a way to photograph wildlife without alarming them. A long telephoto lens lets you get some really close detail in your photos. 400mm (APS); ISO 1000; 1/800 sec at f/8.

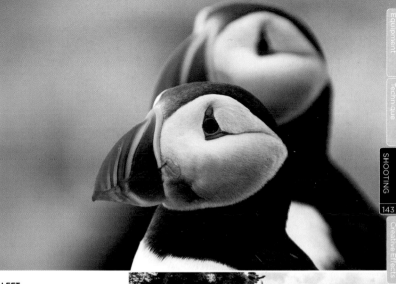

LEFT

Working with a wide-angle lens to provide a background helps give a sense of place to the foreground gull. 52mm (APS); ISO 250; 1/100 sec at f/16.

RIGHT

Photographing from the perspective of the animal adds a more unique dimension. 18mm (APS); ISO 320; 1/60 sec at f/22.

Equipment
Technique
SHOOTING
143
Creative Effects
Editing Workflow
Reference

Stabilized equipment is helpful for hand-holding, but if the animal is moving, the stabilization will let you use a slower shutter speed than is needed to stop action. Action doesn't have to be stopped though; consider panning on the animal or movements to add more drama and interest.

National Parks, wildlife refuges, and sanctuaries offer the best opportunities for experiencing wildlife in their natural setting. The animals aren't hunted, and there are often special viewing platforms and blinds set up. Game parks and farms, zoos, and butterfly gardens are great locations to photograph confined wildlife, but it's best to caption the photos as captive.

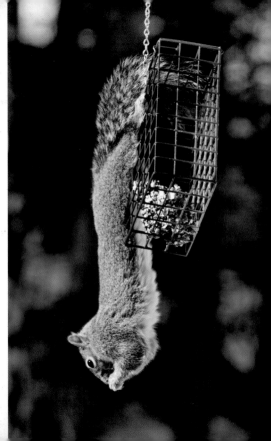

RIGHT
Having feeders around the house opens options for some fun photos. 320mm (APS); ISO 320; 1/100 sec at ƒ/11.

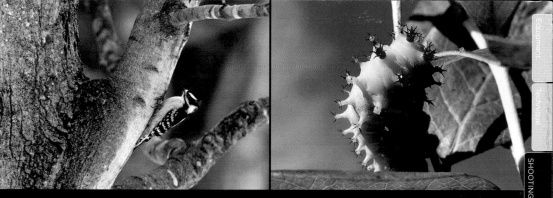

Equipment · Technique · SHOOTING · Creative Effects · Editing Workflow · Reference

ABOVE

This downy woodpecker is a regular at our feeder. 400mm (APS); ISO 400; 1/100 sec at $f/8$.

ABOVE RIGHT

Being observant is important when looking for smaller creatures like this cecropia moth caterpillar in the wild. 24mm lens with an 8mm extension tube (Full); ISO 100: 1/50 sec at $f/22$.

Wildlife Viewing Tips

- Learn about wildlife patterns and habitats with field guides.
- Consider how easy it may be to spook the animal and work from a car or a blind.
- Try to stay downwind so your scent won't be noticed.
- Wear muted natural tones—avoid wearing or working with bright, shiny objects.
- While most wildlife is quite cautious and rather skittish, some animals can be rather bold.
- Let wildlife approach you—don't pursue them. Be wary of their possible intentions—especially during the mating season when they are hormone driven.
- If you move, move slowly, zigzagging around and stopping periodically.
- Look around often so it doesn't seem like you are stalking them.
- Remember you aren't the top of the food chain in some parks and wild landscapes.
- No photo is worth the risk of endangering the life of a wild animal.

Aerial Photography

Photographing from the air offers a unique perspective on the landscape. While photos can be taken from any airplane with a window, when flying in a small fixed-wing aircraft, select one with an overhead wing for a greater variety of shooting angles, and a window that can be opened. Helicopters offer the best option, as the newer models have a very smooth ride, and with the door off there's a full 180 degree hemisphere to shoot from without being affected by the wind. Helicopters aren't limited by elevation constraints so it's just as easy to hover near the ground as it is to cruise a couple of thousand feet up. While a chopper is a more expensive option, you can shoot more photos in the same time frame since it's easier to get into the positions you want, shoot, and move on.

All the usual rules of composition and lighting also apply to aerial landscapes. Lighting can be even more important in the air because of the amount of atmosphere between you and the ground. Also, higher moisture-content air adds haze and a bluish cast which needs to be color-balanced in post-processing. Working with an extended-range zoom lens offers the greatest shooting options and minimizes lens changes. The 18–200mm lens on my APS sensor D300S handles almost any aerial shooting situation. Longer length lenses are tougher to hold steady on a subject. Ultra wide-angle lenses tend to have

RIGHT
Since it's not possible to open a window at 37,000 feet, place the lens right against the window to cut down on reflections from light in the plane. This also softens any imperfections on the window itself. 35mm (Full); ISO 100; 1/200 sec at ƒ/5.6.

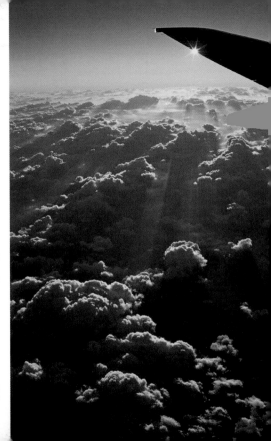

RIGHT

A helicopter offers a broad view of the landscape and has options for hovering and shooting at low elevations. 10mm (APS); ISO 200; 1/320 sec at ƒ/8.

BELOW RIGHT

Aerial shooting provides a way to use views, angles, and details that aren't possible otherwise. 20mm (APS); ISO 200; 1/640 sec at ƒ/5.6.

some perspective distortion, and it is harder to compose without including parts of the plane. Since the point of focus is generally at infinity and depth of field is not critical, shoot with a wider open aperture for faster shutter speeds that help eliminate camera shake issues. It's good to keep a stabilized lens out of the wind—the winds just outside the window play havoc with the stabilizer.

I like to carry along two cameras, each with different lenses for varying situations. I also run into occasional camera-buffer issues with aerial photography. I may shoot sporadically when flying to a location, but then shoot a barrage of images at different focal lengths and angles. If the camera can't write the Raw files fast enough, I can grab the other camera and keep on shooting.

Be sure to keep the camera strap around your neck when the window is open, and keep any potentially loose parts safely in a camera bag. There's not much extra room in a cockpit, so travel light and compact. Remember to carry additional fresh batteries and memory cards. It's easy to go through them quickly when photographing from a plane.

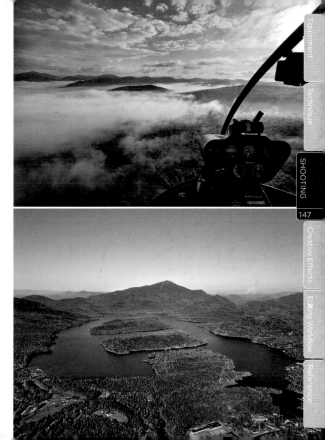

Underwater Photography

While serious underwater photography requires some pretty sophisticated equipment housings and attachments, it's easy to use one of the waterproof point-and-shoot cameras for just playing around while swimming or snorkeling. The simplest underwater housings are protective watertight bags with a glass "window" for the lens. These are fine for shallow water use; more serious housings are specific to each camera model so controls can be accessed underwater. Different size lens ports are available, and there are also contacts to attach underwater strobes. Some of the best underwater housings are safe for water depths of up to 100 meters.

Since warm color tones are quickly absorbed by water, underwater landscapes have a blue–green cast. Because of this color shift, most underwater photographers rely on strobes to pick up the natural tones and try to take a photo within three feet of an underwater subject. Water clarity is very important. A flash will bounce off any suspended particles in the water and can fill a scene with pinpoints of light—although a quantity of fine particulate in the water does help create underwater sun bursts and shafts.

Waterproof housings open up lots of photo possibilities for shooting everything from curling and crashing ocean waves, to over/under photos, also called split-shots. Because of optical differences and the magnification factor between shooting above and below the water, it is best to use ultra wide-angle or fish-eye lenses to have enough depth of field so both portions can be in focus. Focus on the underwater details, and use a small aperture of $f/16$ or smaller so the above water portion is also in focus.

Water cuts down on the amount of available light, so shooting while the sun is overhead and behind you helps puts the above/below portions of the image in closer tonal balance. Since there is still a difference of an f-stop or two (more as the depth increases), expose for the above-water portion, and then bracket for the underwater portion to have the exposures needed for HDR work in post-processing. Strobes could also be used to enhance the underwater area.

There are a number of suggestions for minimizing water droplets on the lens dome for over and under shots. Wiping it with baby shampoo or potatoes is suggested about as often as simply spitting on the glass. Other suggestions are Stoner glass cleaner, Rain-X, anti-fogging solutions for diving, and toothpaste. Both Rain-X and toothpaste aren't recommended, since Rain-X causes water to bead and isn't good for acrylic—and toothpaste generally contains a mild abrasive. Wiping the surface with a freshly cut potato, or spitting on it (or licking it), then wiping the spit around and doing a quick rinse before shooting, seem to be the most eco-friendly and easiest ways to help eliminate water droplets.

RIGHT

Another option for underwater and over/under shots is to shoot with the camera in a small aquarium. Propping it at the right angle on the stream bed for this shot let me do long exposures and HDR bracketing as well. It might not be quite as sharp and accurate as underwater housing with a large dome port, but it offers an inexpensive way to play! 10mm (APS); ISO 200; 1 sec at $f/22$.

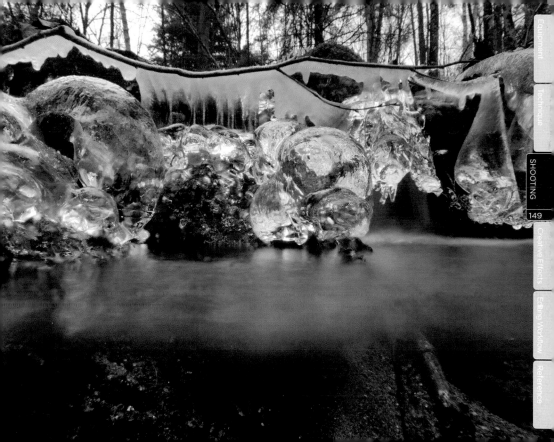

Equipment

Technique

SHOOTING

149

Creative Effects

Editing Workflow

Reference

CREATIVE EFFECTS

"What if?" is the most basic creative question. What if I adjusted the depth of field, used a much longer shutter speed, or played with the focus? What if I panned the camera, changed the zoom, jumped up and down, or even tossed the camera up in the air while it was taking a picture? There's nothing to lose (as long as you catch the camera), and plenty to gain.

Digital cameras provided me with a freedom to photograph that I didn't realize I was missing. There were techniques I thought about trying with film, but didn't experiment with because of the costs and limitations. Digital technology provides the opportunity to immediately review the results of an experiment, making it easier to refine the effects for successive images. The more you pursue new and fresh ideas, the more you'll be able to expand.

Equipment

Technique

Shooting

CREATIVE EFFECTS

151

Editing Workflow

Reference

Creative thinking comes from asking questions rather than having the answers. Simply asking "What if?" creates infinite possibilities. Seeing creatively helps for visualizing images where they don't yet exist and finding opportunities where you don't see any answers. The end results are up to your imagination, plus understanding the dynamic relationship between the aperture, shutter, and ISO.

Creative photography is about playing with the camera and experimenting with ideas. Try thinking from different angles and perspectives, and using different lenses, attachments, filters, and techniques. Walk, run, or jump with the camera while taking a photo, or take some photos while skiing down a path or riding on a bike (safely). Let go of composition rules and preconceptions and just play with the settings, experiment, and try whatever comes to mind. There's nothing to lose, and everything to gain. Slow down, relax, and let your mind wander—the questions and answers will come to you, rather than you running after them.

LEFT

I had experimented previously with holding the camera steady and also panning an image in the same exposure. I tried a few times before I got one I thought had the right amount of blur and sharpness. 170mm (APS); ISO 200; 1/8 sec at f/20.

Selective Focus and Diffusion

Diffusion adds a wonderful ethereal effect to a photograph. While we generally strive for a clean, sharp focus, working with selective focus and other options to add diffusion to an image opens numerous creative options. I'll sometimes shoot one image in focus and another one in soft focus so I can either combine them in the camera with Image Overlay, or later on with post-processing.

When creating diffusion through selective focus, the amount of the image in focus is directly related to the diameter of the aperture and the focal length of the lens. Using the largest aperture and longer focal lengths will show the most diffusion in out-of-focus areas. Full-frame sensors are an advantage over smaller ones since the proportionately longer lenses used have less depth of field for the same field of view. Some lenses,

though, have softer diffusion—or a better bokeh—in the out-of-focus areas. This is lens specific, not focal-length specific, and is related to how circular the aperture opening is and the quality of the light transmission through the glass.

Working with long lenses and a teleconverter, or macro lenses, lets you focus on very specific lines in a subject while the rest of the image has a very soft background. Setting up quite close to leaves or other foreground details lets you focus "through" them, adding even greater diffusion to the image. Check the composition with the depth of field preview button to physically see how much of the image is in focus at the selected aperture.

Diffusion can also be created in many other ways. In addition to shooting options in the field, there are also digital options for creating diffusion during post-processing.

LEFT

Adding an extension tube to a 70–200mm zoom gives macro capability and adds diffusion to the already minimal depth of field of those focal lengths. Setting up with the front of the lens quite close to the closest tulips gives the effect of focusing through the softness. 350mm (Full); ISO 200; 1/ 60 sec at $f/8$.

Equipment

Technique

Shooting

CREATIVE
EFFECTS

153

Editing Workflow

Reference

ABOVE

Lensbabies offer various creative options which all have an adjustable "sweet spot" of sharpness that transitions into the surrounding softness. Lensbaby Composer (Full); ISO 100; 1/30 sec at $f/8$.

LEFT

I experimented with different aperture settings to see which worked best for the flower detail. A wider aperture made the image too soft. With a smaller aperture, the detail in the background became distracting. $f/18$ was actually a mid-size aperture at these settings on this macro lens. 105mm (APS); ISO 100; 1/6 sec at $f/18$.

ABOVE

Pinpoints of lights—like these LED Christmas lights—create intriguing orbs of light
when photographed out of focus through a large aperture opening. 120mm (APS);
ISO 200; 1/10 sec at $f/5.6$.

ABOVE

The moisture from breathing on a lens's front filter adds varying degrees of diffusion that changes as it evaporates. 10mm (APS); ISO 100; 1/5 sec at ƒ/22.

ABOVE

This image was photographed through a 1/4-inch-thick plate of ice broken out of a puddle. I shifted it around until I found the desired effect. Cellophane, plastic, panty hose, and many clear and translucent materials can be used to create diffusion and selective focus. 35mm (Full); ISO 100; 1/100 sec at ƒ/16.

Equipment

Technique

Shooting

CREATIVE
EFFECTS

155

Editing Workflow

Reference

Image Diffusion Options

- Diffusion/soft-focus filters.
- Soft focus "portrait" lenses with adjustable softness.
- Lensbaby options which feature a moveable/adjustable sweet spot of clarity.
- Teleconverters magnify a scene while keeping the near focus distance, for a corresponding decrease in depth of field and greater diffusion at the same distance.
- Experiment with selective focus using longer lenses, large apertures, teleconverters, or macro lenses with minimal depth of field. Use the depth-of-field preview button to check composition.
- Breathe on the front filter and shoot through the variations as the moisture evaporates.
- Petroleum jelly—smear on an old filter leaving a clear section in the middle (or not).

- Place neutral-toned panty hose over the lens (with a long enough focal length so the mesh is not apparent in the image).
- Atmospheric conditions can soften and diffuse an image during longer exposures (mist, fog, snowstorm, or heavy rain).
- Intentionally shooting points of light out of focus turns them into light "orbs" (sunlight on dewdrops, city lights, Christmas decorations).
- Shoot through contoured transparent glass or a sheet of ice.
- The "Orton" effect—a multiple exposure composite with one shot in focus and the other soft (page 161).
- Post-processing techniques—duplicate the background layer, use a Gaussian Blur, then adjust the layer opacity to blend it with the sharp-focus background. Add a layer mask to fine-tune the blur in sections of the image. Work with various types of blur or try software specifically designed for soft-focus effects.

Panning and Motion Blur

Adjusting the shutter-speed controls how motion is portrayed in a photograph. Faster shutter speeds can stop subject motion, while slower shutter speeds record the motion as a soft blur. Choosing an effective shutter speed for stop action or blur is dependent on the speed of the subject, the focal-length lens being used, and whether the subject is moving across the field of view, or in line with the camera.

One of the most common uses of motion blur is photographing moving water. Mount the camera securely on a tripod and work with a shutter speed of about 10/focal length or longer for moving water in a stream, river, ocean, or waterfall to create a gentle motion blur. With exposure times of near 30 seconds or longer, motion lines may disappear into a soft misty effect. Too much softness blurs the power of large waterfalls. A shutter speed of about 1/focal length stops the action at the top of the falls, and allows a soft motion blur near the bottom. This helps portray the energy of the drop and the volume of water.

Panning uses camera motion to show action by tracking a moving subject while blurring the background. This technique can be applied to any subject in motion—people, cars, animals, falling leaves, snow, and water dropping over a waterfall. For best results, use a shutter speed of about 2–4/focal length, and track the subject with the camera before, during, and after taking the photos. Set the camera on continuous shooting, take

RIGHT
Long exposures of water provide a soft, gentle feel. 24mm (Full); ISO 100; 1/2 sec. at *f*/16.

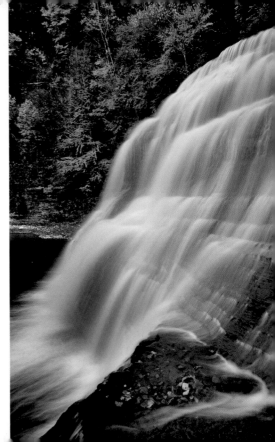

Equipment

Technique

Shooting

CREATIVE EFFECTS

157

Editing Workflow

Reference

ABOVE

I used a shutter speed fast enough to stop most of the action, but slow enough to allow some motion at the tips of the wings. 200mm (Full); ISO 100; 1/160 sec at ƒ/8.

BELOW

Zooming during a longer exposure flares details from the center of the image. Zoomed from 112 to a shorter focal length with my 18–200 zoom. 112mm (APS); ISO 320; 1/6 sec at ƒ/5.6.

ABOVE

I played with holding the zoom lens barrel still and rotating the camera body a number of times before getting the effect the way I wanted it. Zoomed from 135 to a shorter focal length with my 18–200mm zoom. Rotation started at 135mm (APS); ISO 200; 1/6 sec at ƒ/29.

successive images, and keep both eyes open so you can follow the subject with one eye while the shutter is closed. Use a stabilized lens if possible.

Panning isn't limited to moving subjects, you can also pan the lines of stationary subjects. Try panning the lines of trees into a base of snow, water, flowers, or grass, and experiment with city or Christmas lights, buildings, water, or reflections. Experiment by panning the camera at different angles, or in a circular motion. Or try shooting while running, jumping, skiing, or walking—or keep the camera locked on a specific subject, and shoot while walking or driving by. The options are endless once you move past holding the camera as still as possible.

TOP LEFT
There are magical patterns everywhere. For this shot of rippled reflections, fall leaves, trees, and blue sky, the camera was rotated around the zoom. 150mm (APS); ISO 160; 1/6 sec at f/11.

ABOVE
Long exposures of water soften details in faster motion, and create beautiful swirls out of the slowly rotating foam. 11mm (APS); ISO 200; 15 sec at f/8.

ABOVE RIGHT
It can take a number of tries to get it right, but panning is an effective way to portray motion. 100mm (APS); ISO 100; 1/30 sec at f/22.

Zoom lenses open up additional possibilities for slow shutter speed creativity. Zooming during a slow exposure flares details from the center to the edges of an image. I often try this with an exposure of about 1/6 second—but experiment with the exposure time as well as the speed at which you adjust the zoom. Another option for a rotating zoom lens is to rotate the camera around the lens while taking a photo. Hold the barrel of the zoom still, and then rotate the camera during the exposure. When done just right, this creates a whirlpool blur that swirls from a specific point in the photo.

Once you've practiced some of the previous motion techniques, add another "twist" to the exposure. Using a stabilized lens, hold the camera still for a portion of the exposure, then pan or zoom it for the remainder. This can produce a photo with a sharp image blended with the motion. Enjoy—and let your imagination and creativity run wild!

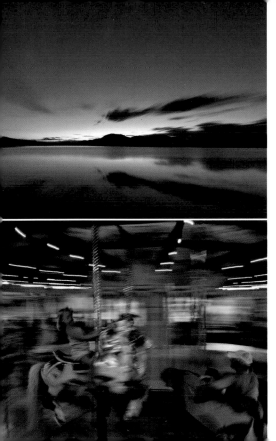

LEFT

Extra long exposures soften cloud movement, and soften any detail in the water ripples. 11mm (APS); ISO 100; multiple of ten exposures at 10 sec each at *f*/22.

BELOW

There were lots of different motions going on when panning on this rotating carousel. 28mm (Full); ISO 100; 1/15 sec at *f*/8.

Tips

- Subjects moving across the field of view require a considerably faster shutter speed to stop the action compared to a subject moving toward or away from the camera.
- The necessary shutter speed required to stop action is related to both the speed of the subject and the focal length of the lens. For many subjects moving in line with the camera this is about 1/focal length.
- The shutter speed needed to blur the background during panning is related to both the speed of the subject and the amount of background blur desired. A shutter speed about 1 to 2 *f*-stops less than that needed to stop action will create a nice background blur with most lenses and moving subjects. (Approximately 2–4/focal length)
- Photographing ocean waves as the shoreline water from the previous wave is retreating into a building wave gives better dimension and energy to the wave than a slow exposure of the wave breaking and rolling in.
- Experiment—and bracket both the shutter speed as well as the exposure.

Multiple Exposures and Image Compositing

Combining exposures provides different ways to add artistic effects and work with motion. If the camera doesn't include a multiple-exposure choice in the shooting menu, many of the techniques can be replicated in post-processing. Multiple exposure has two shooting options: Auto Gain Off, and Auto Gain On.

Working with Auto Gain off , each exposure in the multiples sequence is additive. For example, let's use a setting of $f/8$ at 1 second. Without changing the aperture, 1 exposure at 1 second is the same as a composite of 2 taken at 1/2 second, 4 at 1/4 second, 8 at 1/8 second, or 10 at 1/10 second. Image information in the sequence is combined at the intensity at which it was shot. This method works with shorter shutter speeds that are in proportion to the number of photos being combined. With Auto Gain on, each image is shot at a normal exposure. The camera combines information from each of the images in the sequence and averages the exposure. This allows you to shoot each image as you see it, and the camera will composite the overall image information into a single exposure. When working with longer exposures that contain some motion blur, compositing multiple images compiles the blur as if shooting an extra-long exposure.

Image Overlay is another option found on some camera models that creates a multiple exposure in the camera of any pair of Raw or JPEG files. The selected images can each be adjusted for intensity, and then composited into an additional image file without affecting each original. The resulting file can be combined with additional images one at a time.

TOP RIGHT

While a single exposure was 5 sec, as the light of the day was fading, the longest exposure I could achieve with camera settings was 5 seconds. A multiple exposure with 10 images gave the motion-blur effect of a 50 sec exposure.

RIGHT

This multiple exposure of witch hopple blossoms is a composite of a still image and a zoom blur.

BELOW RIGHT

The main image of the birch tree branches was about half of this exposure, with eight more exposures of branches adding detail for the other half of the exposure.

BOTTOM RIGHT

Combining a main sharp exposure along with a less intense panned exposure created a nice soft, windblown effect for this winter landscape.

Equipment
Technique
Shooting
CREATIVE EFFECTS
161
Editing Workflow
Reference

Multiple exposure chart with Auto Gain Off

Exposures are additive. For example, compositing two exposures of ½ second gives the same amount of light as one at 1 second, four exposures at ¼ second, or 10 exposures at ¹⁄₁₀ second.

Number of exposures (gain off)	1	2	3	4	6	8	10
Fractional amount of the total exposure	1	½	⅓	¼	⅙	⅛	¹⁄₁₀
Underexposure compensation (stops)	0	1	1 ½	2	2 ½	3	3 ⅓

ABOVE

Compositing a sharp image, with an out-of-focus one creates a rather dreamy Orton-style effect.

ABOVE RIGHT

Underexposure Compensation can be used to set the correct exposure needed for different numbers of multiples when doing a Multiple Exposure sequence with Auto Gain turned off.

Multiple Exposure Options

- Composite two different subjects—such as the full moon and another landscape image, or a close-up of a leaf and detail of a stream.
- Composite two different textures of the same image—such as one in focus and one out of focus (as in an Orton)—or a zoom blur or panned blur over a sharp image.
- Portray motion for the same subject—as in multiple superimposed quick shots of a flag waving instead of doing a longer exposure blur.
- Composite a number of exposures with very slight composition movement between each one for an impressionistic effect.
- Expose one image with greater intensity than the rest for more emphasis on a certain subject. For example, shoot the first one at 1/2 the full exposure (1 stop underexposed). That leaves another 1/2 second to be broken into either two at 1/4 the full exposure (2 f-stops underexposed),
four at 1/8 (3 f-stops underexposed), or eight at 1/16 (4 f-stops underexposed).
- Work with a dark background, a moving subject and a flash unit to do multiple-exposure sequences of a dancer, or other subject in motion.
- Multiple exposure can also be used instead of, or in addition to, a neutral density (ND) filter for longer exposures than normal. Set the camera to the lowest ISO and smallest aperture for the slowest possible shutter speed. With Auto Gain on, shoot a multiple exposure sequence of the same scene. A composite of six multiples is the same as a 6 f-stop ND filter, and 10 multiples equals a 10 f-stop ND filter.
- Use a tripod, cable release and mirror lock-up or Exposure Delay mode to prevent camera motion between successive images.
- Post-processing compositing—add image files as layers in image-editing programs, and adjust the placement and opacity of each layer for the effect you want.

Interval Timer and Time-lapse

An interval timer is used to shoot a set of images at precise intervals over a specific period of time. These images can be used as separate frames for a time-lapse video sequence or used as separate images to record the various stages of an event. Sequences can be of anything that changes with time, such as a flower blossoming, a sun or moon rise or set, city traffic, wildlife movement, or a storm passing by. Separate images may be composited into a single one in the camera if the interval timer is used in conjunction with multiple exposure. If your camera doesn't have an interval timer, there are remotes for different camera models that have interval timers built in.

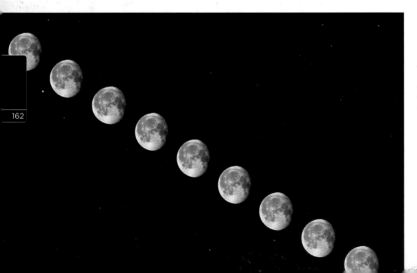

LEFT

I used multiple exposure with Auto Gain off, to combine a sequence of nine interval timer 200mm at 1/125 photos, shot three minutes apart, each during the moon's motion across the sky, with an additional 30 second exposure of the sky and stars near the moon taken with a focal length of 18mm (APS); ISO 200.

Equipment

Technique

Shooting

CREATIVE EFFECTS

163

Workflow

Reference

LEFT, TOP TO BOTTOM

These JPEG images were pulled from a time-lapse sunrise sequence. These were shot 15 minutes apart (APS). Using Manual mode, I very gradually adjusted exposure during the sequence from 1/3 sec on the darkest, to 1/100 sec on the lightest.

Interval Timer Tips

- Start with a fresh battery, or use an extended-life battery pack, or hook up to AC power.
- Check that the custom "auto meter off" setting is set to infinity, or to a length of time that is longer than that needed for the image sequence.
- For consistency in exposure when shooting time-lapse for video, set the auto-exposure button to "hold" in the custom settings. Lock the exposure with this option when starting a time-lapse sequence so there is no exposure "jumping" in the final video sequence. Or, use Manual mode to hold the settings throughout a sequence.
- Video is generally 30 frames per second, so it will take 30 separate images to make up one second of video.
- For 1080p video an image only needs to be 1920 pixels wide, but a larger size gives more options for final framing.
- Shoot JPEGs at the highest quality for a video sequence so color work doesn't need to be done on Raw files for each image frame.
- Consider how much the light changes during a sunrise or sunset sequence. The Exposure Value Chart on page 54 can be helpful in determining a base exposure to work with. For example, a sunrise sequence will start darker and end lighter. Lens flare becomes an issue when photographing toward the sun.
- The interval timer can be used in conjunction with the multiple-exposure function (on cameras with this capability) to composite a programed sequence into a single image. Set and initiate the multiple exposure first, then program and start the interval timer. Be sure to press "OK" on each to start each process.
- Sequenced images can be composited one by one with Image Overlay in the camera, or collectively in layers with an adjustable opacity in an image-editing program during post-processing.
- A flash can also be integrated with each image.

Flash and Artificial Light

I prefer working with existing natural light, but sometimes an image can be enhanced by artificial light. While a flash is the most common artificial lighting source, flashlights, headlamps, lanterns, and laser pens are also options.

For landscapes, I generally use a flash to "fill in" shadowed subjects, highlight a specific subject, or to enhance an area that is darker than the rest of the image. I'll usually underexpose the flash by about one f-stop, or more sometimes if just adding a few highlights. With through-the-lens metering technology, using a flash is as simple as popping up the built-in flash (or adding one or more accessory flash units) and adjusting the Flash Exposure Compensation. A built-in flash can be used directly, or softened through attachments so there aren't harsh shadows (though there are many more options for external flash units, which also have their own power supply). Accessory units can be positioned so the flash reflects onto the subject from a reflector or umbrella. When using a built-in flash, remove the lens hood to eliminate shadows from the hood. Use either, or both, flash bracketing and exposure bracketing as needed.

Handheld artificial lighting provides more unique results. During long exposures at night, parts of the landscape can be "painted" with a flash, or with a headlamp or flashlight. Choose a lamp with a diffused, rather than focused beam of light, for

164

ABOVE

This photo is a combination of stars being shot near the end of twilight, light from the quarter moon on the mist, some headlamp "painting" on the dock and chairs, plus lighting from the headlights of a car that had come in on the road behind me, highlighting the mist beyond the chairs. 10mm (APS); ISO 800; 60 sec at $f/4$.

RIGHT

Once it is dark enough, artificial lighting from towns and cities can illuminate low clouds, creating a unique combination of glowing clouds, stars, and deep blue sky. 26mm (APS); ISO 400; 27 sec at $f/4$.

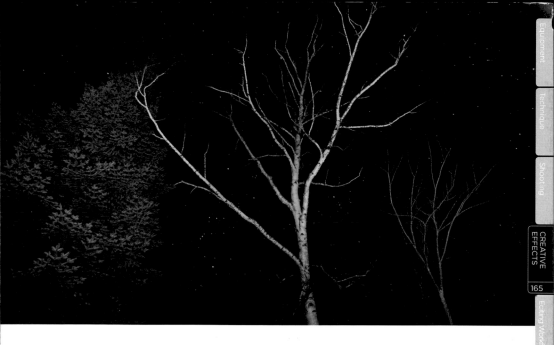

Equipment

Technique

Shooting

CREATIVE EFFECTS

165

Editing Workflow

Reference

lighting a broad area with a soft glow. Move the light back and forth, and around the subjects to be highlighted. Colored filters can be used to adjust the hue of the normally bluish LEDs. Laser pens, or lights with a single small bulb can be used to outline objects or write mid-air comments. Remember, writing needs to be done backwards to show up correctly in a photo.

ABOVE

I "painted" the trees with my LED headlamp during this 30 sec exposure of the stars. How much "painting" needs to be done depends on the intensity of the light source(s), and the ISO being used. 11mm (APS); ISO 400; 30 sec at $f/2.8$.

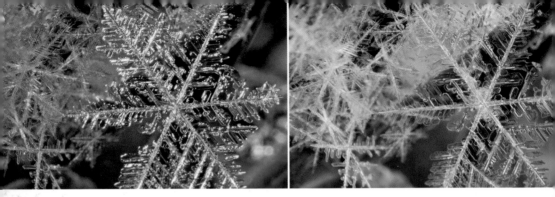

ABOVE, LEFT AND RIGHT
This comparison shows the dramatic difference on this snowflake macro between using a flash or not. The entire feel of the image changed with the use of a fill-flash. Photographed with a reversed 24mm lens (APS) at ƒ/22. Exposure of 2.5 sec without the flash, 1/2 with; 2-stop flash underexposure compensation; ISO 200.

During a long exposure, you can walk in and out of the landscape without being "seen" by the camera, as long as there is no light falling on you. Lanterns or lamps can be used to light up tents from the inside, giving a warm feeling to a night scene. Subjects can be lit from the front and side, or even backlit in misty conditions, which creates an ethereal glow around an object.

Flash Options

- Front-Curtain Sync: The flash fires at the beginning of every exposure.
- Rear-Curtain Sync: The flash fires at the end of the exposure, so a moving subject is highlighted at the end of the exposure instead of the beginning. A moving subject will be on top of any light "trails," rather than underneath them (as with slow sync).
- Slow Sync: Can be used with exposures up to 30 seconds to help preserve colors in night and twilight photos.
- Red-Eye Reduction: The bright AF-assist light or a quick flash series fires before the main flash exposure, helping reduce the red-eye effect with people and animals.
- Red-Eye Reduction with Slow Sync: For a mix of ambient lighting and a softer feel to the flash, the red-eye reduction flash is used with longer exposures for twilight and night photos.

TOP LEFT

I was intent on the soft glow of the red lights on Niagara Falls in the evening twilight as well as the children that had just run under the spray, and didn't realize until later, that perhaps a subtle fill-flash would have helped to highlight the foreground slightly. 24mm (Full); ISO 100; 2 sec at f/16.

TOP RIGHT

Photographed after the sun had gone down, I accentuated the foreground with a 1 f-stop underexposed fill-flash that balanced nicely with the rest of the image. 24mm (Full); ISO 100; 1/60 sec at f/22.

LEFT

In daylight a flash can be used to fill in shadows in a person's face, or any other subject. 13mm (APS); ISO 200; 2 sec at f/22.

EDITING WORKFLOW

Digital photography provides the opportunity for everyone to become an artist. From the spark of creation to final publication, digital technology gives each of us full control over every image we create. Understanding the camera principles and being able to capture your vision is only the first part of the process—image processing and enhancement also need to be done before final presentation.

I quickly realized the potential for digital imaging after I began scanning my transparencies and enhancing them with Photoshop 4.0 back in 1997. It wasn't long before I began thinking of each of my transparencies as "information," rather than being the final photograph. The more information I had to work with in an image file, or set of images, the easier it was to recreate my initial vision. I was no longer limited by working with filters to tame and enhance the lighting for a more natural look, I could now composite bracketed exposures of the same image to better recreate what my eye saw when I was there, and come closer to my intent when I clicked the shutter.

Digital photography is as much about post processing as it is about capturing the image information in the field. Composition, lighting, and technique all still need to be just right, but we now have great flexibility in the final image interpretation and presentation. Knowing what can be done in post processing gives a better understanding of the steps involved in capturing the information necessary to fulfill our inspiration. If computer work isn't for you then set up the camera to refine your images as you shoot them, and simply enjoy shooting JPEGs. However, be sure to shoot and bracket some Raw files of critical scenes so you'll have everything needed to create the best presentation when that extraordinary image comes along.

LEFT
A workshop group photographing near the end of a day's shoot in the Adirondack High Peaks, Adirondack Park, NY.

Storage and Backing up

After the light has faded and the equipment is put away, it's time to take a closer look at the results of the shoot, do some quick image editing, and back up the photo files. How much I do each night depends on how many images I shot during the day, whether I have access to power, and how much sleep I might get.

Some days I just work with memory cards, but there always comes a time when images need to be downloaded to more permanent storage, sorted for quality and tonal capture, added into a database, and edited for color. I typically travel with at least two 8GB cards plus two 16GB cards which can hold a lot of images, as well as video.

Since I usually carry two camera bodies with an extra battery for each, I have four batteries, which has always been more than enough for a day of landscape photography. When I'm traveling in a car, I'll set up a charger with an inverter, plus I have an additional charger to use when I'm back in a motel room for the night. In the room, the first step is start the download process, and next I'll put the batteries in the charger so everything is ready to go at first light.

I generally do my editing on a computer, but there are times I will critique, edit, and delete files in the camera first. I go through the same process I do for computer editing—checking the composition, histogram, and zoom into each image file to check sharpness in every part of the image. If it passes all the tests, it's a keeper—along with any bracketed shots in the set that are needed for tonal information.

The first line of storage is simply that, a place to put the

Storage Options

- A laptop with a large capacity hard drive is the most versatile field unit. In addition to storage, synchronized copies of your database and image-editing systems make field editing easy. Plus you can stay in touch with the weather and email with a satellite connection, or if there are nearby wireless hubs.
- Laptops can be used in conjunction with external hard drives or portable storage devices for safe backing up of files.
- A portable storage device with built-in card reader is a relatively inexpensive way to clean off the more expensive memory cards. Look for large capacity drives with fast transfer speeds and long battery life, and make sure it will copy and store Raw, video, and any other media files you use. Note that some are built just for storage, more expensive models also have an image viewer.
- Having extra memory cards is an easy, compact way to store images in the field.
- Images can be burned to DVD, but that can take some time, plus quite a number of DVDs if you're storing a large number of Raw files.
- Battery chargers can be used with a DC/AC power inverter that plugs into a car's cigarette lighter.
- Lightweight, fold-up solar panel battery chargers can help keep all your electronics running when there is no power source.

files until they can be critiqued, edited, and grouped in more permanent storage. In addition to storing image files on a hard drive in the office computer for long-term storage and easy access, we also back up on external hard drives. Nothing is completely safe, so it's good to have a backup for the backups. We use duplicate high-capacity hard drives. One pair set in the office mirrors our image files, working files and OS backups. These are swapped regularly with a duplicate pair we keep in off-premises storage. Off-premises storage can be as simple as a fireproof box at a friend or relative's house, or a safe deposit box.

BELOW, LEFT TO RIGHT

No matter how you choose to transfer the files from your memory card to your computer, a card reader is the fastest option for copying your images.

Hard drives can be so small that they fit on your key ring. However, larger versions such as this HP model can hold more than a terabyte of data and are better value.

Combining storage with viewing capabilities, the Epson P7000 has a 160GB hard drive that provides plenty of space also allows you to shoot with it tethered to your camera, providing instant backup and viewing options.

ABOVE

Although high capacity cards are available, such as the 64GB card, many professionals prefer to use a greater number of smaller capacity cards: if one fails, they have others they can still use.

Equipment
Technique
Shooting
Creative Effects
EDITING WORKFLOW
171
Reference

Image Review and Database Processing

Finding a box of slides in the mailbox was almost like being a child on Christmas morning. I'd tear off the plastic wrap, remove the protective sleeve, open the yellow and red box, and hold the magical transparencies up to the light. I was always curious about the whole set, but sometimes looked for a particular image to see if it had come out like I hoped. However, it was only after the slides were spread out across a light table and thoroughly checked using a loupe that I could see exactly which slides were special gifts, and which were lumps of coal.

Aperture and Lightroom are the most popular programs for reviewing, cataloguing, and batch processing images. Extensis Portfolio has been used for our database since long before these programs were available, so we still review images as before, using Adobe Bridge. It's good to remember that the software isn't as important as the process.

Seeing digital photos for the first time on a big screen still brings some surprises as well as disappointments. Even though the image has already been checked thoroughly on the camera, seeing it at full-screen size and critiquing it against others is the

Image Review Steps

- In Bridge and Lightroom to be sure you are viewing exactly what you shot, turn off "Apply auto tone adjustments" in the program preferences. In Lightroom work in Library mode.
- Review images at a large size for overall composition, and delete files that just don't work.
- Next (in Bridge/filmstrip mode) I'll open each image in the Raw conversion software.
- Note that clipped (overexposed) highlights appear in red, and clipped shadow detail appears in blue.
- Move the black point to (0) and also check the tonal range with the histogram. Save any file that contributes to the full tonal range for HDR work.
- Then check the sharpness in "Details." Push the sharpness to the

highest level, and check all parts of the image for necessary sharpness. These steps are just to assess files. Once they have been checked, click "Cancel" to close the image so no changes are saved.
- At the same time, image files that are part of a bracketed set or panoramic sequence are renumbered. Each file in the set is given the same image number, followed by a different letter. All are checked for quality.
- Be sure to embed contact and copyright info into the metadata of the final selection of images. (In Lightroom, files have to be selected and then saved with any changed metadata.)
- Finally, add database information, location, description and so on, and save changes as needed.

Equipment

Technique

Shooting

Creative Effects

EDITING
WORKFLOW

173

Reference

LEFT

Reviewing images in Adobe Bridge from a fall photo shoot, and using the magnifier to check a section of the image.

real moment of truth. Always keep in mind the potential Raw files have for enhancements with editing work. An image is a "keeper" as long as it has good composition, necessary tonal range, and sharpness. I have found my personal preferences change over time, so as long as the image is "good," I'll add it to the database.

After a shoot, I set up a new folder (named by date) within a main folder that I keep for recent Raw files. Once I have edited a date's folder, the Raw files go into number-coded storage folders, where the uniquely numbered image files are easily accessed for high-res color work. I keep all original files with potential uses.

JPEGs created from each saved image file (one JPEG for a bracketed set) are placed in another folder structure that is set up by country/state/region/local categories. This structure is used within our Portfolio database system, offering another way to view images in addition to the powerful search features. Even with tens of thousands of images, our database system can be easily transferred to another computer without needing to access the considerably larger Raw storage folders.

Image Editing and Enhancement

A big part of image editing is knowing how you want the final image to appear and understanding the potential to make that happen. Color enhancement is a process with one step building on the other. Experimenting will help you better understand the process and what each option has to offer.

Editing programs work in two different ways. Some programs work with "sidecar" files that contain the recipe for all of the enhancement work that was applied to an image. With an Adobe program, such as Lightroom, this is an XMP file. If the sidecar file is eliminated, the image file reverts to its original state. With a layer-based editing system like Photoshop, enhancement work is added as a layer on top of the base image. Each layer increases the file size, but the layers can easily be independently readjusted and masked at any point in the editing process. In order to rework the file in the future, it must be saved as a layered file with all the layers intact.

Lightroom features a well rounded mix of functions, including image review and database functions in Library mode, image-enhancement features in Develop mode, and easy ways to create and upload galleries for the Internet in Web mode. If you regularly work with images that have a lot of similarities, Lightroom also has some powerful batch processing features for color work, and also features printing and simple slide show functions.

While programs like Lightroom and Aperture have extensive image-editing potential, we do all of our color work in Photoshop because of the power of image editing with layers. Photoshop Elements has extensive layer editing capability that is sufficient for many photographers, but has reduced functions when compared with the full version of Photoshop. Many of the color adjustments we work with in Photoshop are similar to editing features found in Lightroom, but we prefer fine tuning images with Photoshop's layer system.

Monitor Calibration

Before doing any color work, it is important to know that what you are seeing on the screen is what you'll be getting in print. Your monitor is the weak link, and needs to be calibrated to industry standards so your image file will look the same when it prints, as well as when seen on anyone else's calibrated system. We use the Colorvision Spyder system, but there are other systems that can be used also. Follow the directions and try it a couple of times so you are comfortable with the calibration process. When done properly, your printer output should pretty closely match the colors you see on your monitor when using manufacturer profiles for the paper and ink.

Raw Conversion

Our first step in color work is to open the Raw file—whether from Bridge, or directly from Photoshop. The file will open in the Raw Conversion software. Choose both the color space and bit depth at the bottom of the conversion page. We use Adobe RGB, 16-bit (default is 8-bit). This becomes the default selection until you change it—or reinstall the software. Adobe RGB has more color information than sRGB, which gives greater options during color work. However, the color tones exceed the

ABOVE
My selection in Adobe Bridge of the three different exposure choices for HDR work.

ABOVE
Opening the midtone image file with the Raw conversion software. Note the reds showing where detail has been clipped in the highlights. I've added some recovery, and moved blacks all the way to the left. White balance is still as shot.

color gamut (range of color) of printers, so the file needs to be translated to the printer profile for printing.

The only adjustments we generally make when converting Raw files are: Moving the black point to the left to pick up as much shadow detail as we can, using recovery to help pull in highlight detail; and occasionally adjust exposure but no more than about + / – 1.0. If a file has close highlight/shadow tolerances but still needs some HDR work, you can open two versions of the same Raw file; one at + 1.0 exposure and another at – 1.0 exposure and combine them in Photoshop using HDR layers and masking.

Any chromatic aberration issues such as color fringing, as well as perspective issues, can be adjusted during the Raw conversion under the Lens Correction tab. These issues can also be corrected in Lightroom (Develop/Detail) or Photoshop CS5 (Filters/Lens Corrections).

Setting up Photoshop

There are some setup features in Photoshop we like to change. Under Edit/Preferences/General we check "Resize Image During Paste" and "Zoom Resizes Windows." Under Interface we

Equipment

Technique

Shooting

Creative Effects

EDITING
WORKFLOW

175

Reference

uncheck "Open Documents as Tabs." Under Performance, be sure to select a hard drive that has plenty of space for a scratch disk. You can also adjust the number of History states you'd like to be able to use.

Also adjust Edit/Color Settings. Click on "More Options." Under Working space, choose your color space. We work with Adobe RGB. Under Color management all settings should be "Preserve Embedded Profiles." We use the standard Conversion Options—Adobe ACE, Relative Colorimetric, and all three boxes checked.

Working with JPEGs

When working with a JPEG file, save it as a TIFF file (File/ Save as) as soon as you open it in Photoshop. A JPEG is limited to an 8-bit file, plus each time you re-save it as a JPEG, the actual file information changes. Converting it to a 16-bit mode (Image/ Mode/16 bit), provides more latitude for image correction.

HDR by Hand

Since the image I chose needs extensive HDR work (the process of combining various exposures to create a single image that encompasses a greater dynamic range), I will open three files.

ABOVE
These are the three different exposures before any blending or color work has been done

Most times, two files are sufficient, but for this image I want one file for the shadow detail (the lightest image), another for the midtones, and the third for the brightest highlight detail (the darkest image). The HDR work will be layered with the lightest image as the background, progressing to the darkest image as the top layer.

HDR can be done automatically in various programs, including Photoshop. However, we like the control and more natural effect we get when doing the work by hand. It is a process of layering and masking to bring out the details you want to contribute from each layer. It's essential the images match perfectly. This is easiest with images that were shot on a sturdy tripod using either Exposure Delay mode or the mirror lock, so the frames align pixel for pixel. However, if there is some specific subject movement between frames that needs to be cleaned up, the masking can be adjusted to accommodate the detail as needed.

First, select the Move tool (top of the toolbox, hold the shift key down when you use it so the moved image will auto-align). Then click on the mid-toned image to select it and drag it

it onto the lightest image, and move it so it aligns over the light-toned background. Next, check to see that they are perfectly aligned. Highlight the top layer in the Layer palette, and adjust the Opacity (at the top of the Layer palette) to about 50 percent. Adjust the overall image size to 100 percent to see any differences (Ctrl + to size up/Ctrl—to size down/Ctrl 0 to size to the screen). Then click on the eye to the left of Layer 1 to turn it off—and on—and note any discrepancies between the layers. If need be, the top layer can be "nudged" with the arrow keys, or adjusted for shape with a transform tool (Edit/Transform/Warp or Distort). The transform tools are especially helpful for aligning a handheld bracketed sequence for HDR.

Once the layers are aligned, begin the masking process. Add a mask to Layer 1 (Add layer mask—at the bottom left of the layer palette). Once the mask is created, click on it to be sure it's the active box—so you are masking the layer—and not erasing the actual image information. A mask can be adjusted again but if you are on the background, once information is erased you can't bring it back! However, it's easy to backtrack steps in the History palette by just clicking on a previous state or action in the list. (Also Edit/Undo).

Click on the eraser tool in the toolbox (about half way down). Change the eraser tool colors to black and white by clicking on the small black/white icon just above the background/foreground color boxes at the bottom of the toolbox palette. Change the foreground to white by clicking on the arrows to the right of the icon. Adjust the opacity of the brush in the menu bar near the top of the screen to about 10 to 20 percent. Adjust the

hardness of the brush in the brush preset picker to a very soft-edged brush. Adjust the size also, or use the right and left bracket key to size the brush larger or smaller (brackets are just right of the "P" on the keyboard).

Click and hold the mouse as you drag the brush across the image. Note how the background layer begins to show through. Each time you release the mouse button and click again, an additional amount will be "erased", which in this case, adds detail into the image from the lighter background.

To see the mask that has been created on the image, hit the backslash key and the mask will appear on the image in tones of red. Sections of this visible mask can be erased by switching the foreground color to black. Changing it back to white lets you visibly add to the mask with the eraser tool. Hit the backslash key again and the mask will become invisible. The mask icon associated with each layer shows the effect of any masking.

Next I'll move the darkest layer on top of Layer 1 and align it. I only want to bring in slight highlight detail, so I will mask the whole image first. Create a mask, and fill it with black by hitting either Ctrl-Backspace to fill with the background color, or Alt-Backspace to fill with the foreground color (depending on whether the foreground or background is black). This completely masks all details in Layer 2. Now, with the foreground color as black, use a very low opacity and completely soft eraser to brush across the image where you want to bring out the highlight detail. Gradually bring in the detail with a number of passes until you have the desired effect.

Equipment

Technique

Shooting

Creative Effects

EDITING
WORKFLOW

177

Reference

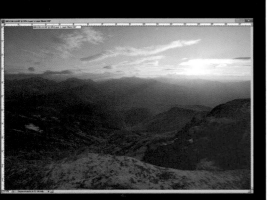

RIGHT

Hitting the backslash key shows the mask that has been applied to the midtone exposure file (Layer 1).

RIGHT

Both exposures have been added as layers to the lightest one and masked to allow an effective blending of shadow, midtone, and highlight detail.

While this may seem slow and technical, once you've practiced this a few times, it begins to go quickly unless there is a lot of edge detail to mask. The great thing is it eliminates the surreal look and halos that come from doing extensive HDR in an automated program.

Color Work

Now it's time to begin actual color enhancement work by creating a composited layer to work from. Highlight all three layers in the layer palette (the two layers plus the background). On a PC, right click/duplicate layers (on Mac holding the control button down brings up the right-click menu). Turn off the eyes to the left of the background and lowest two layers so only the duplicates are highlighted. Rick click/merge visible (or Layer/ Merge Visible). The result should be one composited HDR layer with the three original unchecked layers underneath.

Dusting

This composited layer needs to be checked for dust, since it is now the base layer for the final photo. If you are working with a single image that is the background, this should be dusted also. This is the only work we ever perform directly on the background. Dust the image after sizing it to 100%.

Use the Clone tool, Spot Healing brush, or Healing Brush to clean up any spots on the image. To use the Clone tool, or Healing Brush, Alt-click on the detail to copy from, and then click on the location you want to copy to. If aligned is checked,

the selection location and the brush will maintain the original alignment. Otherwise the selection point stays the same. Adjust the brush tip size and hardness as needed.

Shadows/Highlights

We do a Shadows/Highlights adjustment on almost every image we work on to help bring up detail and better tonal balance. If you are following the instructions for creating HDR images, after you have created a new layer by merging the visible layers, you should duplicate that layer before using the Shadows/Highlights tool. This is so you can apply a mask and erase any unwanted adjustments.

When the Background is the base image layer, click on it to highlight it, then right click /Duplicate Layer. Shadows/ Highlights should be applied to a layer, and not the actual Background. That way a mask can be added to the background copy layer and the effect of the Shadows/Highlights can be masked, adjusted, or deleted if necessary. The background layer remains untouched and can be accessed any time. Select *Image > Adjustments > Shadows/Highlights*. Check "Show More Options" to see all the sliders and adjust them as is best for the image. You can adjust and save new defaults. I use defaults of (Shadows: 35, 35, 150) (Highlights: 0, 50, 30) (Color correction +20, Midtone—0), which is a good place to start, though these are often changed later on. If needed, add a mask from the bottom left of the layer palette and erase percentages of any of the layer where the effect is more than needed. Double click the name of the layer and rename it Shadows/Highlights.

LEFT

The three base layers have been duplicated, and the lower three have been turned off. The next step is Merge Visible to blend the three duplicated layers.

LEFT AND BELOW

The duplicated layers have been composited using "Merge Visible." I've renamed the layer and show the menu settings used for this Shadows Highlights.

Equipment

Technique

Shooting

Creative Effects

EDITING WORKFLOW

179

Reference

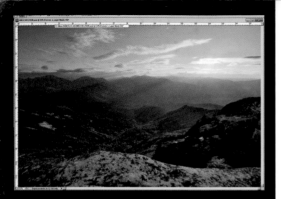

ABOVE
Slightly raising the highlights
and lowering the shadows,
while holding the
black-and-white points builds
greater contrast in the image.

Color Enhancements

Photoshop's color adjustment layers provide infinite color adjustment possibilities. Each gets added as an additional layer on top of the previous one, and affects all layers below it. Add layers by either clicking the "New Layer" icon at the bottom center of the layer palette, or Layer/New Adjustment Layer in the top menu. The Layer/New Adjustment Layer option offers a way for the adjustment layer to affect only the previous layer by checking "Use Previous Layer To Create Clipping Mask." This can be helpful for fine-tuning specific selections.

Adjustment layers all have a mask icon for fine-tuning the effect of each layer. All layers can be adjusted for "Opacity" (top right of the layer palette), and also the mode can be changed (top left in the layer palette). For example, if the mode is changed to Luminosity it affects only the brightness of each color and not the actual color tone. Layers can also be dragged from one level to another. The layer order can change how the layers affect the colors in the image.

After creating the Shadows/Highlights layer (if necessary), I'll sometimes add a Vibrance layer to gently saturate colors without clipping them. Check to see what is affected in the image by pushing the slider to an excessive amount, and then bring it back to a reasonable level. That way you can see what is directly being affected and adjust accordingly.

Follow the Vibrance layer with Hue/Saturation. In addition to the "Master" RGB saturation, each of the main colors can also be saturated individually and adjusted for lightness. Hue/Saturation can add its own level of brightness, so it is better to

add that before working on contrast in the image. Contrast can be enhanced with Brightness/Contrast, Exposure, Levels or Curves. Each has a similar effect but can adjust the image in different ways. Exposure is an easy way to lighten the midtones by sliding the Gamma slider to the left, create some contrast with negative Offset, and add some brightness by adding Exposure. Curves can add contrast by selecting a point on the graph on the right half and pulling the line up to brighten the lighter areas. Then select a point on the lower part of the line and pull it down slightly to darken the shadow area.

Another option with both Curves and Levels is to click on "Auto." This is often a quick, easy way to make overall color and tonal adjustment. Adjust the opacity of the layer and do some masking to blend it as needed. Sometimes it doesn't work at all, but it's easy to delete a layer by dragging it down to the garbage can at the lower right of the layer palette (or undo in History). It is worth noting that the Auto layer will work differently after you've done other layer work than if it is the first layer you do.

Color Balance is an easy way to affect the color tones in the shadows, midtones, and highlights. Many times only very slight adjustments give a more natural color tone and brightness to your image. Selective Color provides a way to change the color tones of each of the main color values.

We rarely use the Photo Filters, but this offers digital effects that are similar to using actual filters in the field.

Add a black-and-white layer, tone it, or adjust the mode from "Custom" to "Infrared." Or simply add the layer and adjust the mode in the layer palette to Luminosity so it only affects

RIGHT
I've hit the backslash key to show the mask I added to the Curves layer to minimize the effect in specific areas.

ABOVE
After adding additional layers for color enhancement and contrast, I added another Curves layer, clicked on Auto, and softly masked some of the effect from the brightest part of the image.

Equipment

Technique

Shooting

Creative Effects

EDITING WORKFLOW

181

Reference

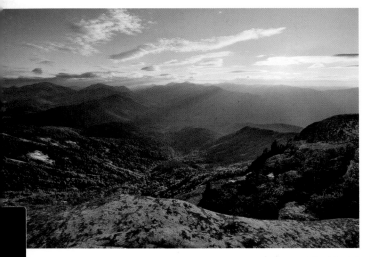

ABOVE
The final rendition of the image with fine, natural-looking detail throughout the photograph.

tonal intensity. Adjust the Opacity, erase the effect as needed, and it becomes a more unique contrast layer.

Experiment and try different options, and you'll soon begin to realize the extensive power of the program. As long as enhancements and changes are only done as additional layers, there is no change to the original image file until the image is flattened (Layer/Flatten image) and saved as a flattened image (TIFF) for printing. Before flattening, we always save our layered work file as a PSD or PSB file so we can easily make additional adjustments at some point in the future. We also know if a file has a PSD or PSB extension, it is a layered image file.

After working on an image, it's good to walk away for a couple of minutes before coming back to take another look. It is easy for your eyes to become accustomed to some unique tones you may have come up with while sitting in front of the monitor. The more you work with image editing, the better you will be at understanding just what needs to be done in post processing, as well as when you're in the field gathering "information" for the final image.

Sharpening

We sharpen detail in the image only after color work has been done, and the file has been flattened and resized or cropped to final dimensions (Image/Image Size or the crop tool). As with everything else in Photoshop there is more than one way to sharpen an image. The quickest is via *Filter > Sharpen > Unsharp Mask*. Don't think about the name—this is the best sharpening tool. Start with a Radius of .5 to 1.0 and a Threshold of 5 to 10. Adjust the Amount after the image is zoomed in to a 100% level so you can easily see the effect.

The radius affects the size of a small halo created around an edge to add definition. Threshold determines the amount of difference between tones for creating an "edge." With a Threshold value too low, too many tiny details can be sharpened. An image is over sharpened when edge detail has narrow dark edges bordered by a lighter one.

Duplicating the background and performing sharpening on a layer opens up masking options. This lets you mask out the sharpening in the sky, and any other place where sharpening may have increased noise or caused other issues.

Sharpening can also be done on separate color tones. While on the duplicate layer, click on "Channels" at the top of the Layer palette. Click independently on Red, Green, and Blue to sharpen each of the color layers individually. Clicking back on RGB brings up the color composite.

Presentation

A print will have the same quality and detail whether it's printed from a 200 dpi file, or a 300 dpi file. That provides a gain in print size from a digital file. We typically print from a 300 dpi file sized to a appropriate dimensions, but for a larger print will resize it to 200 dpi.

We print right from Photoshop, selecting and sizing the paper in the Page Setup, and using the Print Preview option. For color handling we use Photoshop "Manage Colors," select the printer under the Printer Profile, use a Rendering Intent of "Relative Colorimetric," and check "Black Point Compensation." This works well for my situation, but you might want to experiment with different options for your own personal setup.

Images for use on a monitor or the Internet are best sized to 72 dpi at the final dimensions. It's also better to adjust their color profile to sRGB so they are compatible with all the software and hardware they might be seen on.

Sharing your images and seeing them appreciated is the final step. Photography is a wonderful way to be able to share your experiences and visions with others, taking them to locations and conditions they may never experience otherwise.

Equipment

Technique

Shooting

Creative Effects

EDITING WORKFLOW

183

Reference

Digital Workflow

Digital Photography Workflow

1. **Perceive the image** "It's not what we see, it's how we see it."
o Something comes to mind or catches your eye and inspires a photograph

2. **Assess the situation**
o Close one eye and evaluate the potential for a photo

3. **Visualize the scene**
o Consider all the viewpoints, angles and lighting possibilities
o Choose what lens/focal length to use

4. **Compose/Set up the camera**—Shutter controls motion/ Aperture adjusts depth of field
o Consider using a tripod (easier for fine-tuning composition—mandatory for long exposure)
o Figure in depth of field/focus point/motion/ISO speed
o Finalize composition

5. **Shooting process**
o Metering—Evaluative Metering for most situations/Center-weighted Metering/Spot Metering for specific subjects
o Shooting mode—Aperture Priority mode for depth of field/ Shutter Priority mode for motion/Manual for Bulb or fixed settings
o Autofocus/manual focus
o Set amount of bracketing if needed

o Use a cable release whenever the camera is on a tripod— especially for macro and telephoto shots (use mirror lock-up)

6. **Image evaluation** (after taking the shot)—perfect pictures every time
o Check composition—zoom to check for tighter compositions—recompose and shoot again? (crop with the lens—not software)
o Check histogram of the photo and on each bracketed shot as well
o Zoom fully to check sharpness—and compare edges of closest, mid range and farthest subjects of each image

Creative Options

o Diffusion—selective focus or the use of various filters and techniques
o Motion—panning the camera—or subject motion
o Compositing images (multiple exposure or Image Overlay)
o Working with depth of field (digital stacking to increase depth of field)
o Extra long exposures
o Artificial lighting
o Lens choices—telephoto lens (for details), ultra wide-angle lens (for greatest depth of field), Lensbaby lens, fish-eye lens, macro lens, close up diopters, and extension tubes.
o Digital creative options with an imaging program like Photoshop

Image-editing Workflow

1. **Image selection** (Adobe Bridge/Lightroom/Aperture)
o Edit preferences/find and turn off Apply auto-tone adjustments so the monitor shows the exact tonal balance of an image
o Check composition, histogram, sharpness on the computer monitor
o Delete all rejects and unnecessary exposures
o Perform batch-processing in Lightroom/Aperture

2. **Database management**
o Rename/renumber groups of bracketed images (A, B, C, D)
o Caption and copyright all images

3. **Image editing**
o Monitor calibration
o Open Raw file/Raw conversion software settings (I do all color work/noise reduction/sharpening in Photoshop)
o Better to pull highlight detail from a slightly overexposed image than shadow detail from an underexposed one
o Adjust "recovery" as needed for highlight detail
o Move the "black point" to the left as needed for shadow detail
o Adjust "exposure" if needed—but no more than about + / – 1.0
o Open as TIFF/16-bit/Adobe RGB (Elements has limited 16-bit function)
o Layer/masks-based editing program (Photoshop—full or Elements)
o Duplicate background/dust shadow/highlights on the duplicate/add vector mask and mask as needed
o Additional color-enhancing layers as needed (Layer/new adjustment layer)—mask/adjust layer opacity as needed
o Color balance, exposure, curves, vibrance, hue/saturation, brightness/contrast, etc.
o Save layered file (we save as .PSD or .PSB so we know it is a layered file—and use TIFFs or JPEGs for flattened files)

4. **Publish**
o Open, flatten, resize and sharpen at the intended size
o Print from a 200 to 300 dpi file/electronic at 72 dpi (web, slide shows, and so on)

Shooting Guidelines, Formulas, and Tips

Sunny 16 Rule

- Bright sun/distinct shadows 1/ISO at f/16
- Snow/bright sand f/22
- Hazy sun/soft edges to shadows f/11
- Cloudy bright/indistinct shadows f/8
- Overcast or open shade/no shadows f/5.6

Palm of Hand

Use the evaluative meter with the palm in the same plane as the photo with similar shadowing on the palm

Evaluative Metering Landscape Situations

- Green leaves, grass, deep blue sky, even overcast days approximate an 18% gray value
- Snow or bright sand—overexposure compensation—½ stop (some white), to 1 ½ stops (mostly white)
- Fog, mist—overexposure compensation—½ to 1 stop
- Storm clouds—underexposure compensation—½ to 1 stop
- Silhouettes—underexposure compensation 1 to 2 stops
- Stained glass or candles—underexposure compensation—about ½ stop

Situations

- Fireworks—f/8 at ISO 100, (f/11 at ISO 200, etc.)—shoot on Manual/Bulb
- Situations—Lightning bolts—f/11 at 100 ISO—f/16 if close, f/8 if further—Manual/Bulb or Aperture/Shutter Priority
- Rainbows—use the average evaluative meter reading or underexpose ½–1 stop with dark clouds
- Full moon (overhead in night sky) 1/ISO f/11
- Half moon 1/ISO f/8
- Crescent with earthshine—1/ISO at f/5.6—bracket 3–5 stops for the earthshine (HDR)
- Stars—to eliminate star streaking, maximum exposure time is about 1000/focal length (1000/20mm = 50 seconds)
- Star tracks—minimum exposure needed to create a nice trail is about 60,000/focal length (60,000/50mm = 1200 seconds = 20 minutes)

Stop Action

- Minimum shutter speed for hand-holding the camera (no stabilization)—1/focal length
- 45 degree movement—plus 1 stop over approaching stop speed
- 90 degree movement—plus 2 stops

Motion Blur

o Water—10/focal length or longer exposure
o Large waterfall—1/focal length to stop action at the top, with soft motion at the bottom
o Sports or wildlife panning—use a shutter speed about 1 to 2 stops less than needed to stop action (approx. 2–4/focal length)

Bracketing

o Check the histogram (left—black point/right—white point)
o Minimum of 1 stop + / – bracket with digital
o Up to + / – 2 stops covers most contrasty situations
o With high air clarity at sunrise/sunset, might need + / – 3 or 4 stops

Multiple Exposure Guidelines/Chart

o Auto Gain On—camera blends normally exposed images
o Auto Gain Off—exposures are additive. For example, compositing 2 exposures of ½ second gives the same amount of light as 1 at 1 second, 4 exposures at 1/4 second, or 10 exposures at 1/10 second.

Multiple exposure chart with Auto Gain Off

Exposures are additive. For example, compositing two exposures of ½ second gives the same amount of light as one at 1 second, four exposures at ¼ second, or 10 exposures at ¹⁄₁₀ second.

Number of exposures (gain off)	1	2	3	4	6	8	10
Fractional amount of the total exposure	1	½	⅓	¼	⅙	⅛	¹⁄₁₀
Underexposure compensation (stops)	0	1	1 ½	2	2 ½	3	3 ⅓

Glossary

Adobe RGB (1998)—Color space developed by Adobe with a wide color gamut that encompasses most colors that can be reproduced by CMYK printing.

angle of view—Viewing arc of a lens, measured in degrees on the diagonal of the frame. Angle of view is specific to focal length.

artifact—When saving JPEGs, image information is compressed into blocks of similar information that can show up as irregular shapes in even-toned areas of the image.

bit depth—The quantity of tonal variations possible per color per pixel measured in "powers of 2." For example, 8 bit equals 2 to the 8th power, or 256 tonal variations.

blooming—A halo which surrounds a bright source of light. This comes from the overflow of photons to adjacent pixels on a sensor during an exposure.

bokeh—The degree of softness in out-of-focus areas in a photo. Soft, diffuse out-of-focus areas have good "bokeh."

bracket—Shooting additional frames of exactly the same scene with varying under/over exposure.

bulb (setting)—A manual mode for holding the shutter open.

CMYK (cyan, magenta, yellow, black)—Subtractive inks used for printing, where color values of the primary colors are combined on a sheet of paper to produce the full spectrum of color in an image. Combining a full intensity of each ink creates black, while 0 percent of each is white.

chromatic aberration—When a lens cannot focus each of the primary colors on a specific point, colored fringes appear around lines of contrast.

clipping—When tonal information in a scene falls beyond the white or black exposure point of a sensor (or film), that information will appear as either white, or black.

color gamut—Describes the range of colors that can be produced by a digital output device.

color model (color space)—An abstract mathematical model describing the way colors can be represented in numerical values using three or four primary values or color components (RGB/CMYK/CIE Lab).

color profile (ICC profile)—This defines the colors available for a particular device to help translate accurate color model information from one device to another.

depth of field—This is the distance between the nearest and farthest subjects in a photographic composition that have acceptable sharpness.

diffraction—Light rays are disturbed when passing by an edge, creating a very slight softness that can become more apparent with small aperture settings.

dpi—Dots (or pixels) per inch is used to measure resolution. The resolution needed for apparent clarity varies with different devices.

dynamic range—This refers to the ratio from the brightest to the darkest luminance values, that we can see, or a device can capture.

EXIF (Exchangeable Image File Format)—Embedded image file information containing date and time, shooting data, and any other related metadata.

f-stop—An adjustment by one stop either doubles or halves the amount of light received by the sensor. f-stop refers to aperture adjustment, while "stop" is interchangeable for both aperture and shutter adjustment.

field of view—The relative area of a scene that can be captured by a sensor. Different size sensors using the same size focal length, capture proportionally different fields of view.

gamma—Refers to the overall tonal values of an image. Adjusting the gamma particularly affects the midtone range.

HDR (High Dynamic Range)—Combining images with varied exposures so a single photograph can encompass a greater tonal range.

hyperfocal point—The focal plane distance where necessary foreground and background subjects will have apparent sharpness.

ISO setting—(International Organization for Standardization)—In photography this refers to the sensitivity of the sensor (or film) to light.

incident light—The direct light from a light source. An incident meter reads the light coming directly from the source of light.

lossless—A compression process that retains details for each pixel in an image file.

lossy—An image compression process where similar pixel information is recorded as groups of information. Higher compression leads to the loss of subtle transition details and can create digital artifacts and noise.

neutral density filter—Decreases the amount of light coming through the lens, without affecting the tonal quality. A split neutral density filter is clear on half the glass with a gentle transition to the darkened glass.

noise (digital noise)—A visible tonal difference between pixels as they record subtle differences in light values.

Orton—Refers to the original process of re-photographing a slide sandwich of one sharp and one out-of-focus images.

panning Taking a photograph while tracking a moving subject with an exposure that is slower than that needed to stop the action to create a blurred effect on the background.

pixel—The smallest controllable piece of digital information in an image file.

polarizer (filter)—Cuts down on stray light approaching the filter from oblique angles. It's most effective when used at 90 degrees to the light source.

posterization—A distinct separation of tonal values with a visible banding in an area of similar tonal values.

ProPhoto RGB—A large color space developed by Kodak that encompasses almost 100 percent of the visible spectrum of light. However, about 13 percent of this color space exceeds the normal spectrum and cannot be reproduced.

purple fringing—A chromatic aberration where there is a purplish ghosting effect along high-contrast edges and around various details in a photograph.

reflected light—The indirect light coming from any surface that is not illuminated from within.

RGB (red, green, blue)—The additive primary colors used to create the full palette of color on an illuminated screen. 100 percent absence of any colors creates black, and a 100 percent intensity of each creates white.

sRGB (Standard RGB)—developed as a standard that could work across the full range of media and devices—from the web, to cameras, monitors, and printers

TTL (Through The Lens)—Image metering and evaluation is assessed directly on values and distances being read "through the lens" from the composition itself.

vignette—A darkening effect around the corners and edges of an image created by the shadowing effect of filters added to the front of a lens.

Equipment
Technique
Shooting
Creative Effects
Editing Workflow
REFERENCE
189

Index

3D 90–1

A

accessories 30–3
Adobe
 Bridge 172, 173, 174, 175
 Lightroom 172, 174
 Photoshop 59, 168, 174, 175–6, 180, 183
RGB 18, 174–5, 176
AE/AF-L 21, 69, 73, 93
aerial photography 146–7
aperture 7, 10, 12, 38, 39, 40–5, 153
Aperture Priority mode 7, 10, 11, 12, 38, 39
artificial light 164–7
Auto Gain 19, 160, 161, 162
auto image rotation 22
autofocus 20, 68–9

B

backing up 170–1
batteries 20, 22, 33
bit depth 18
bracketing 57, 64–7, 76, 93, 113, 129, 134, 159, 187
auto-bracketing 10, 12
Bulb setting 11, 28, 112

C

cable release 14, 15, 28, 29, 32
Canon 11, 68
CCD sensor 13
Center-weighted Metering mode 14, 52
clean image sensor 22
close-ups 94–7
CMOS sensor 13, 132
color enhancement 13, 18, 70, 178, 180–2, 185
color temperature 59
Colorvision Spyder 174
composition 13, 70, 73, 75, 76, 80–5
contrast evaluation 80, 84, 87, 92
copyright info 22
custom setting menu 20–1

D

data screen 16, 17
database 172–3, 180, 185
daylight locations 118–29
Deep Sky Stacker 32
depth of field 2, 10, 11, 12, 13, 24, 25, 26, 29, 38, 39, 40–5, 46, 68, 71, 73, 96, 132

diffusion 152–5
digital workflow 184–5
diopters 94
Display Mode 16
dusting 178–9

E

energy and emotion 98–101
Evaluative Metering mode 7, 14, 52, 53, 129, 132, 186
exposure 11–12, 18, 19, 38, 52–7, 160–1, 162, 187
Exposure Compensation 7, 10, 11–12, 14, 20, 38, 39, 53, 55, 56, 65, 129, 161
Exposure Delay 14–15, 20, 22, 142
Exposure Value Chart 54, 55, 132
extension tubes 24, 26, 94, 95, 96

F

f-stops 40
field of view 13, 24, 27
file numbering 20
filters 30–1, 70
fine art 102–5
fireworks 137, 186

firmware updates 22
fish-eye lenses 24, 26, 27, 78
flash 20, 22, 31–2, 141, 163, 164–7
flashlights 32, 132, 164–5
focal length 13, 24–7, 39, 40, 42, 46, 49, 90, 94, 96, 134, 156
focusing 68–9

G

glories 113
golden sections, spirals, and triangles 86–8
Google Maps/Earth 36, 37
GPS devices 36
gray card 55, 57, 59

H

Handheld mode 19, 20
HDR (High Dynamic Range) 12, 28, 64–7, 70, 124, 134, 176–8
headlamps 32, 164–5
Highlights 15, 16, 57, 76, 179, 180
Highlights Enhancement 18
histograms 15, 20–1, 60–3, 64, 65, 66, 76, 129

hyperfocal settings 11, 42, 44, 45, 68, 91, 94, 126, 132

I

image authentication 22
image blends 92–3
image comment 22
image compositing 160–1
image dust off reference photo 22
image editing 174–83, 185
Image Overlay 152, 160
image quality 18
image review 16, 172–3
image size 18
in-between light 131
interlaced video 72
interval timer 19, 22, 162–3
ISO settings 10, 11, 13, 18–19, 38, 39, 50–1

J

JPEG files 12–13, 18, 30, 58, 71, 160, 169, 173, 176

L

LCD screen 13–14, 19, 20, 22, 32, 83
Lensbaby 26, 33, 153, 155

lenses, choosing 24–7
light orbs 155
light shafts 113
lightning 108, 112, 186
lines 86–9
LiveView 14, 19, 22, 68, 69, 142
locations 36–7, 106–7, 118–29, 130–7
Long Exposure Noise Reduction 18, 132
low-light 11, 15, 28

M
macro lenses 15, 20, 24, 26, 94, 95, 96
magic hour light 120–1
manual focus 68–9
Manual mode 10, 11, 39, 163
Matrix Metering 14
memory cards 20, 21, 33, 170, 171
metering 14, 38, 39, 52–7
midday light 124–5
Mirror Lock-up 14, 20, 142
mirrors 14, 15
monitor calibration 174
moon 36, 71, 134-5, 186
motion 46–9, 98, 99, 105

motion blur 46, 49, 156–9, 186
multiple exposure 19, 20, 22, 136, 137, 160–1, 162, 187

N
nighttime locations 130–7
Nikon 11, 14–15, 16, 135
Noblex panorama camera 98, 108, 124, 139

O
Olympus 11
Orton effect 155, 161
outdoor gear 34–5
overcast conditions 128

P
packs 9, 34
palm of hand 55, 57, 186
panning 49, 156–9
panoramas 11, 92–3
patterns 86–9
people 11, 138–41
personalized menu 22
playback menu 16
polarizer 124
post processing 18, 70–1, 146, 152, 155, 169–83

presentation 183
Program mode 7, 20, 38
progressive video 72

R
rain cover 32
rainbows 113, 186
Raw Conversion 174–5
Raw files 10, 12–13, 18, 22, 30, 58, 71, 160, 169, 173
red skies 109, 110–11
reflected light 126–7
reflectors 32
reverse lens adapter 96
rotate tall 16
rule of thirds 80, 84, 85

S
safety 34–5, 112
seasons 114–17
selective focus 152–5
self-timer 15
sense of place 106–7
sensors 13, 22, 24, 25, 33, 42, 46, 90
setting up 16–23
setup menu 22
Shadows/Highlights 179, 180
sharpening 183

shooting menu 18–19
Shutter Priority mode 7, 10, 11, 38, 39, 46
shutter speed 10, 11, 15, 20, 29, 38, 39, 46–9, 51, 134, 159
silhouettes 55, 141
Spot Metering mode 14, 52
stars and trails 32, 136, 164, 186
stitching software 92, 93
stop action 47, 49, 51, 98, 156, 157, 159, 186
storage 9, 33, 170–1
strobe 32
sun pillars 113
Sunny 16 rule 55, 57, 58–9, 134, 186
sunrise/sunset 36, 55, 57, 101, 103, 129

T
teleconverter 24, 26, 94, 155
telephoto lenses 15, 20, 24, 26, 27, 40, 47, 88, 90, 94, 97, 136, 142
textures 86–9
TIFF files 58, 176, 182
tilt-shift lenses 26

time lapse 19, 73, 162–3
Tripod mode 19
tripods 9, 14, 15, 20, 28–9

U
underwater photography 148–9

V
video 22, 72–3, 162, 163
viewfinder 13, 14, 20, 76, 77, 80, 83, 93, 142
virtual horizon 22, 23, 132
visualization 78–9

W
waterproof cases 32
weather 10, 32, 35, 108–13
white balance 18, 22, 58–9, 70
wide angle lenses 13, 24, 27, 40, 89, 90, 91, 96, 97, 119, 126, 136, 142, 146
wildlife 11, 13, 142–5
wireless remote 28

Z
zoom lenses 9, 24, 25, 26, 40, 42–3, 96, 158

Acknowledgments

Many years ago I picked up a copy of Kodak's *Pocket Guide to 35mm Photography*, and greatly appreciated the wealth of information it contained, as well as how concise and compact it was. I added my own set of notes and shooting specs inside the cover, and referred to the booklet often as I was exploring the fundamentals of photography. Several years ago I started working on ideas for my own field guide. My goal was to create an informative, compact publication that is full of photo tips, techniques, and shooting information, and could be easily referenced in the field. I was quite happy that folks at Ilex Press appreciated my ideas, and it's been a real pleasure to work with them once again, as well as with Focal Press, to publish this new field guide.

I have thoroughly enjoyed working with my editors at Ilex Press, Natalia Price-Cabrera, and Tara Gallagher. They have been very helpful with suggestions and planning, keeping the project on track, and maintaining my intent for the book while paring text and photo choices to fit the space. I would also like to thank Adam Juniper of Ilex, for his help and his work in editing the original proposal for this book. My thanks also go to James Hollywell, Art Director at Ilex, and Jon Allan, the book's designer. There were numerous others who have helped in many different ways.

I have also appreciated being able to research and fact check some of the more technical aspects of digital photography by using the Internet, and would like to express my appreciation in particular for those behind the scenes at The Luminous Landscape, and Cambridge in Colour. I also appreciate how helpful both Nikon and Canon reps have been with answers to specific equipment questions I came up with. I would also like to thank everyone involved with the North American Nature Photography Association for their efforts to promote nature and landscape photography.

I would especially like to thank my wife, Meg, for all of her support throughout the project. Meg helped create the time and space for me to work on the book while she picked up on details in the business and at home. And, I was only able to wrap up this book close to schedule, with the help of my daughter, Greta. Greta is the wizard behind most of our Photoshop work and prepped most of the images for the book. She also reviewed and edited my post-processing chapter in the book. It is always a great pleasure to work with her in our office as well as collaborate with her on projects like this.

I have found my photography workshops are a wonderful sharing of knowledge, and I have learned much from being able to view the landscape through participants' viewpoints, knowledge, vision, and questions.